YOUR INNER CRITIC IS A BIG JERK

YOUR INNER CRITIC IS A BIG JERK

And Other Truths About Being Creative

DANIELLE KRYSA

PAINTINGS BY MARTHA RICH

CHRONICLE BOOKS
SAN FRANCISCO

Library of Congress Cataloging-in-Publication
Data:
Names: Krysa, Danielle, author.
Title: Your inner critic is a big jerk : and other
truths about being creative /
 By Danielle Krysa ; With illustrations by
Martha Rich.
Description: San Francisco : Chronicle Books,
2016.
Identifiers: LCCN 2015037482 |
ISBN 9781452148441
Subjects: LCSH: Creative ability.
Classification: LCC BF408 .K79 2016 | DDC
153.3/5—dc23 LC record available at http://
lccn.loc.gov/2015037482

Manufactured in China

Chronicle books and gifts are available at
special quantity discounts to corporations,
professional associations, literacy programs,
and other organizations. For details and
discount information, please contact our
premiums department at corporatesales@
chroniclebooks.com or at 1-800-759-0190.

Chronicle Books LLC
680 Second Street
San Francisco, California 94107

www.chroniclebooks.com

10 9 8 7 6 5 4 3 2

TO EVERYONE WHO IS DETERMINED TO LIVE A CREATIVE LIFE,
NO MATTER WHAT THE JERKS SAY.

CONTENTS

Introduction

This is an incredibly white, empty page. And you're the one who's supposed to fill it? You can't write a whole book. Um, hello, you're not even a "writer"!

Seriously. *Such* a jerk.

When I was given the green light to write this book, I was beyond thrilled. I had so many ideas that I could not wait to share. I thought I'd jump right into this exciting new adventure with no fear, but I have to admit that I procrastinated in as many ways as I possibly could. Kickoff meeting with one of my most favorite artists in the world, Martha Rich: Check. Rereading my initial pitch fifty times: Check. Purchase of hot-pink notebook to capture all of my brilliant ideas: Check. Yet, days rolled into weeks. Deadlines loomed. And the thrilling—terrifying—task remained undone.

I thought I'd have no self-doubt while writing this book. I was excited. I was ready! Things changed when I came face-to-face with the blank white rectangle and blinking cursor of Microsoft Word. There was a small—all right, fairly large—panic attack, and a very long lecture from my inner critic.

I've had issues with my inner critic for decades. I'm pretty sure it stems from a terrible critique that I had in my last year of art school (more on that later) twenty-plus years ago. Thankfully, that experience is probably what led to the launching of my art blog, The Jealous Curator, in 2009. I love my site, and it has changed my life in many ways. I went from feeling completely alone in my creative jealousy to being surrounded by thousands of supportive, like-minded readers. By sharing the work of contemporary artists that initially had made me jealous, I slowly began

to realize that there is absolutely no need to be jealous. There is a place for anyone who wants to be creative. Somewhere along the way, that toxic, soul-crushing jealousy turned into inspirational, get-your-ass-back-into-the-studio motivation. What a relief.

I was slowly starting to figure it all out; then, what brought things into focus for me was *Creative Block*, the first book I wrote.

Well, you didn't really write it. You interviewed a bunch of artists from around the world. They "wrote" it, you just asked the questions. How hard can that be?

Sorry, that was my inner critic again. Anyway, as I was saying before I was so rudely interrupted, in *Creative Block* I asked full-time, successful artists about blocks, self-doubt, and the dreaded inner critic. I had no idea how they would answer my questions. I assumed that most of them would respond with, "Inner critic? Ah, no, I don't have that. Inner critics are for amateurs." But their collective answers stunned me. People who I'd assumed had this whole creative thing figured out actually felt just like me—and like you, and every other creative person in the world.

We all get blocked. We are all plagued by an inner critic. And no one is immune to the creativity-halting effects of negative criticism.

It's true. And as I traveled around promoting *Creative Block*, hearing the stories of hundreds of people, I found myself knee-deep in a pile of truths about what it means to be a creative person. Ten truths, in fact—one for each chapter of this book.

These truths run the gamut—from dealing with soul-crushing negative criticism, to quieting bitter inner critics. We'll face the fact that a blank page can be absolutely terrifying and learn how to navigate around it. We'll talk about turning green-eyed jealousy into a green light for your creativity, about failing until we're geniuses, and about the importance of finding a

group of trusted people with whom to share our work, and
our journey.

I wrote this book because I want every creative person to
know that we are all part of a huge, amazing, talented group of
people. We know that being a creative person can feel quite
isolating, but *none* of us is actually alone. Everyone has experi-
enced some, if not all of these truths along the way, even the
professionals, but people rarely talk about it—hence, feeling
alone. Read this book from start to finish, or jump around from
chapter to chapter. Find the stories that strike a chord with you
and your creative pursuits. I made sure to leave a little extra
room in the margins of this book for jotting down thoughts or
realizations that may pop into your head as you read. I'm a big
fan of taking notes, says the girl with the hot-pink notebook.

I hope that these ten truths bring you the clarifying, freeing
aha moments that I've experienced, thanks to the openness
and honesty of so many of you.

See you on the other side.

CHAPTER 1: EVERYONE IS CREATIVE

"Art Facts: First, art is fun. Then, art is creative. Finally, art is beautiful. ART!!!!" —Esmé, age six

Very wise words from a very smart little girl. Whether you paint, or sing, or write, or dance, I'm sure you remember feeling that kind of joy, even if it is a bit foggy now. That's why we need clever kids like Esmé to remind us that everyone—and I mean *everyone*—is creative.

That's a fact. Every single one of us is born with an imagination, and a primal urge to make things—things like fire, and cities, and cakes, and books, and shoes, and vegetable gardens, and breakfast. There are a ridiculous number of ways to be creative. Look at you, for example. Whether you're currently living a creative life or not, you want to. There's no way you'd pick up a book about "inner critics" and "other truths about being creative" if you weren't creative.

I wish I had a dollar for every time someone said, "Me? No, I'm not creative." I would be a gazillionaire. The thing is, that's not really them talking, it's their jerkface inner critic. Okay, so maybe you haven't made anything in a *very* long time, but that doesn't mean you're not creative. What it means is that, somewhere along the way, you became *really* good at saying, "Me? No, I'm not creative." (Cha-ching—there's another dollar in my pocket.) If you feel that way, let's change your mind.

FIND THE FUN.

I'm going to ask you to take a deep breath, relax your shoulders, and think back to when you were little—to a time when you drew, and wrote, and sang, and put on plays for the sole purpose of having fun.

Ah, those were the days. We were completely free to be creative. We stuck macaroni onto feathers with glitter glue simply because we knew it would be amazing. We created homemade books because there was a story that *had* to be told. There was no pressure to be published, and no need to worry about what galleries might be looking for this year. It was before any of us cared about getting into art school, or having our work written about.

That said, not everyone has warm, sunny memories of childhood creativity—and I have a theory about that. I don't want to get ahead of myself (see Chapter 7: No One Can Wrestle the Pencil Out of Your Hand), but perhaps one of the reasons people tell themselves, "Me? No, I'm not creative," is that someone else said it first. Perhaps a cranky first-grade teacher held up that macaroni-feather masterpiece in front of the entire class and deemed it a glittery mess. This makes me so angry. And, FYI, stories like that are ridiculously common.

"Every child is an artist. The problem is how to remain an artist once we grow up." —Pablo Picasso

Are you an artist?

I ask this question a lot. Generally, this question is met with a pause and a slightly blank look. In that moment I can almost hear the inner dialogue: "Um. Artist? Well, no. I make stuff. Sometimes. But an 'Artist' with a capital A? I want to say yes, but that would be terrifying." What actually comes out of the person's mouth is usually, "Oh. Uh, not really." I should mention that this answer, and those blank looks, are *always* from adults. When I ask kids the same question, I get a very different response. It goes a little something like this:

Me: "Are you an artist?"
Kid: "Yes."

No hesitation. No thinking it over first. They have never sold a painting, or published a story, but they have absolutely no problem answering me with a loud, resounding yes. And here's an even more interesting tidbit—even professional artists don't always answer that question with confidence. In my first book, *Creative Block*, I asked all fifty of the very accomplished visual artists that I interviewed how they felt about the title of "Artist." Here are a couple of their answers:

Jessica Bell (Canadian mixed-media artist):
Q. How do you feel about describing yourself as an artist?
A. *The "feeling" that I am an artist is still pretty elusive to me, rather like the feeling of being a grown-up. But other people tell me that I am an artist, and I tell myself that I am an artist, regardless of how I feel.*
Camilla Engman (Swedish painter/illustrator):
Q. Describe the first time that you truly felt like an artist.
A. *I still have my doubts.*

Perhaps that's modesty talking, but isn't it interesting that "yes" doesn't come quickly and easily? It is a little reassuring, though, to realize that these successful, full-time, working artists have to convince themselves that they too deserve this title. Calling yourself an artist may be something you need to work on—quite literally. I've started practicing in the mirror. "Yes, I'm an artist. I'm a collage artist?" *Note: Try not to make it sound like a question next time.* Trey Speegle, a very successful New York–based artist, who has worked on projects with Stella McCartney and Michelle Obama, told me an amazing story around "owning it." This is how Trey learned how to use the "A" word:

> "I got a job working for a magazine at age seventeen, while I was still in high school. I was an art director by age nineteen; and at twenty-one, somehow, I ended up in New York at *Vogue*. I was friends with a lot of artists, photographers, and performers in New York City in the mid-eighties but I had a 'real' job, so I kept making art on the side while working at my day job. Until I inherited my dead friend's paint-by-number collection and merged it with the word-art I was doing at the time, I really never even thought of calling myself the 'A' word. I had so many successful artist friends, like Keith Haring, Kenny Scharf, etc., that I couldn't really call myself one and mean it.
>
> "I think the first time I ever admitted it was filling out one of those landing forms when you are reentering the U.S. I wrote 'Artist' under 'Occupation.' I was sure that the agent was going to see right through me and ask for proof. I did that again and again, until I could finally say it out loud. 'I'm an artist.' It doesn't matter if anybody else thinks you're an artist—if you believe it, and say it, then you are. That's how it works."

Yes. I will *totally* do that on my next flight—and I won't include a question mark.

NURTURED VS. NOT SO MUCH

The people closest to us when we're young are often the ones who give us our creative confidence, whether they realize it or not. When I was three, my mom (who is a very accomplished painter) let me use her oil pastels—risky with a preschooler, but she was always very generous with her supplies, no matter how messy they were. I did a drawing of a very big bird on a very little tree. As I was working on the finishing touches (a tiny yellow sun in the top left corner, of course) my dad leaned over my shoulder for a closer look. He picked it up and said, "Well, we need to frame this." He set up all of the special tools and supplies that he used when he framed my mom's work—he even cut a custom, fancy gold frame for my masterpiece. I remember this like it was yesterday. I remember the overwhelming pride I felt. I remember thinking, and believing, "I am a *real* artist now"—clearly, fancy gold frames from your parents have a lot of power. I still have this drawing hanging in my studio today, and it's still awesome.

Teachers have enormous influence as well. I heard renowned Canadian painter Ian Wallace speak at an event at Emily Carr University in Vancouver. He told the story of his very first breakthrough—the moment he realized that he could be an artist when he grew up. In 1953, Ian was nine years old and his family was about to move away from his very small town. He had

always liked art in school but hadn't given it much thought. His teacher, on the other hand, saw great potential; and so as his going-away gift, the class presented him with an oil paint set. A real one. For grown-ups. Until that moment it had never occurred to Ian that "being an artist" was something he could actually do—his wonderfully supportive teacher and that oil paint kit were the beginning of his path toward a very successful, lifelong career as an influential Canadian artist.

Sadly, not everyone is nurtured in that department. Without support and encouragement from a young age, it's difficult to keep those creative fires burning. Support, or lack thereof, can make a shocking difference in how you view yourself creatively. Yes, I know you're not supposed to care what other people say or think about your work; but we're human, and it's hard to not care. When we were kids, we used our imaginations with complete confidence; but the moment that someone *else* told us that our creations weren't good enough, or, "Hmm, I think you're a better athlete than an artist"—that outside influence started to change how we saw our creative selves. Because of this, many of us give up on our creative pursuits much, much too soon.

We'll talk more about those unwanted bits of criticism later, but the reason I mention them here is just to say, if you believe you're not creative because someone told you that years ago, it *doesn't* mean that you can't find your way back to a time when being creative truly was fun. Here are a few projects that will take you back there, right now.

Projects from the Kindergarten Drawer

• Macaroni Masterpiece: Grab one bag of hard noodles (macaroni, wheels, shells . . . something fun!); pompoms/feathers/glitter—i.e., anything you can find in your house or dollar store; construction paper/cardstock; and, most important, GLUE! I don't need to say anything else, do I? Let the magic begin.

• Fresh Air Foraging: Go for a walk, and look for artifacts that you can collect and bring home—rocks, bottle caps, and flowers or leaves that you can press in a book. Whatever you find, stack it up or arrange it on a piece of paper, and then photograph your final composition. You can stop right there, or you can use this photo of found bits and pieces as the starting point for a collage, painting, sculpture, story, or poem.

• Pancake Pictures: Get yourself a funnel and a hot pan. Pour the pancake batter through the funnel and draw yourself some breakfast. Animals, flowers, the Eiffel Tower—anything! The fantastic thing about this fun, weekend-morning project is that even if it looks terrible, it will still taste delicious. Add whipped cream as needed.

• Blind Contour Buddies: You can do this in a mirror, or with a friend. Look at your reflection (or at your friend) and draw the image without looking at the paper. And, if you want to make it even trickier, don't lift your marker off the page! It will be crazy, and look nothing like your subject, but that's kind of the idea. It's not meant to look perfect; in fact, it's impossible for that to happen. This is a fun thing to do at a dinner party, over drinks.

Well, there you have it—art *is* fun! There are no rules, and no way that you can make a "mistake." All of these projects exist purely for the joy of creating. No pressure. Just silly. An excuse to open a fresh box of crayons. And there's not one cranky first-grade teacher in sight to give her unsolicited opinion.

NO SUCH THING AS "TOO LATE"

Far too often, people tell me, "I wish I hadn't given up on art [or dancing, acting, writing, music], but it's too late now." What! Why? I don't believe that for a second. Many amazingly talented people didn't hit their stride until their thirties, forties, or later.

As far as famous painters go, you don't have to be a child prodigy to be considered one of the greats. Vincent van Gogh didn't start painting until his late twenties and Claude Monet didn't find success until his mid-thirties—late in life for both of them, considering that the average life expectancy was around forty-five! And what about kitchen maven Julia Child? She only began cooking in her late thirties, and didn't publish her first cookbook until she was fifty. One of my favorite stories: Minnie Pwerle, an aboriginal artist whose paintings are shown in prestigious galleries all over Australia, started painting when she turned *eighty*. Yes, I said eighty.

See? It's never ever too late to jump-start your creativity. Have you always wanted to paint? Paint! Sign up for a class, or just get yourself some supplies and start experimenting. You've always dreamed of being on stage? Join a community theater. You don't have to be a star out of the gate, or sell your first painting for ten thousand dollars—just be creative because it brings you joy.

OWN YOUR CREATIVITY.

Creativity comes in so many shapes and sizes. All too often we equate "being creative" with painting perfect portraits, or writing the next great American novel. Why do we do that to ourselves? Throw all of those stupid (sorry, but they *are* stupid) thoughts out the window and decide what being creative means to you. Maybe cake decorating is your jam. Maybe it's the thrill of taking photos from a point of view that is solely your own. Or perhaps you find a tremendous sense of creative freedom in your garden. You might not even know where your sweet spot is right now, but I hope that by the end of this book you feel excited, supported, and ready to stand up and say, "Me? Yes, I'm very creative." If your jerk of an inner critic disagrees, shut it down immediately (we'll talk about *how* to do that in chapter 6).

Regardless of your past experiences, I *know* that there is one fantastic creative memory that you'll never forget. You know the one I'm talking about. When you start to hear your inner critic whispering in your ear, find a quiet spot, take a deep breath, close your eyes, and transport yourself back to that moment. Remember the joy. Remember the pride you felt in yourself for creating that amazing [insert crazy creative thing here]. Remember Esmé's wise words: "Art is fun." Now come back, bringing along a bit of that magic in your back pocket, and get to work.

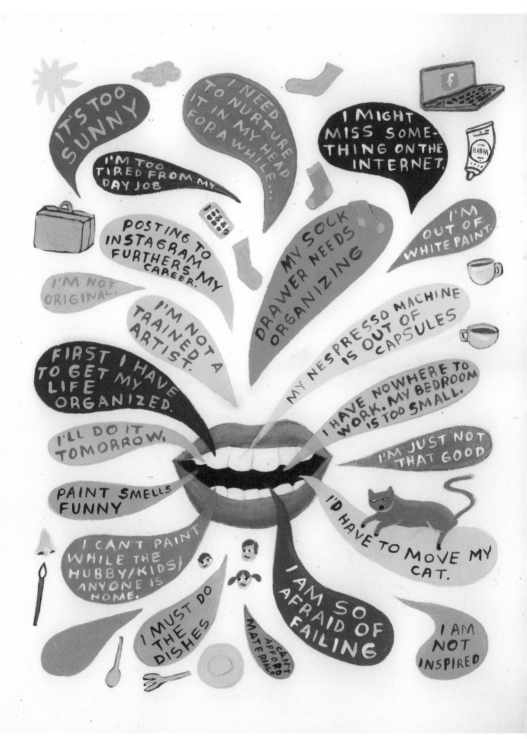

CHAPTER 2: EXCUSES ARE THE ENEMY

The lighting isn't quite right. Work is really busy right now. The house is a mess. You should get to the gym. Have you gone grocery shopping this week? Oh, look, a cute video of a baby duck sleeping on a dog; you should totally watch that before you do anything else.

Excuses. So many excuses to prevent you from doing something creative today. Do you know who I blame? Yes, that jerk of an inner critic. All right, fine; you might actually be busy at work, and you haven't done the dishes since Tuesday, but if you want to find time to be creative, you can. Unfortunately, the second your sneaky inner critic gets a whiff of procrastination, it pounces! A million excuses dumped on the table, burying any chance you might have of making something anytime soon. No matter how elaborate the excuse, this chapter gives you tools for prioritizing your creativity. It's time to take that simmering pot off the back burner and bring it to a full freaking boil.

VALID EXCUSES, SCHMALID EXCUSES

There are lots of valid excuses to call on, and we all use them; but obviously people work past them—or we'd be living in a world without art, books, songs, or movies.

I knew my own list of excuses, but I wondered if I was the only person clever enough to blame my dogs, or the temperature in my studio, or the brightness of the sun, or, well, you get the idea. So I reached out to my readers and asked:

"What is the best excuse you use to keep your creative life on the back burner?"

I received hundreds of responses. Some answers were funny, others were heartbreaking; but all were totally honest—and all too familiar. Amateurs and professionals jumped at the chance to share the lies they tell themselves—lies that, strangely, fit quite neatly into four buckets. Here are a handful of the answers that I got back.

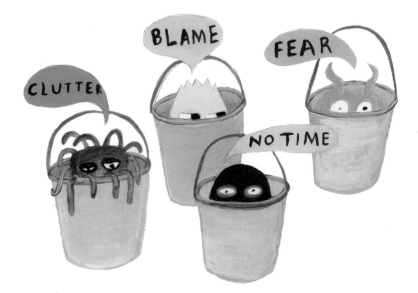

BUCKETS OF LIES
WE TELL OURSELVES

BUCKET NO. 1: FEAR

- "I'm so afraid of failing."
- "It won't turn out the way I imagined, anyway."
- "I just leafed through a book about X [any inspiring artist will do], and I'll never be able to make such impressive work."
- "So many ideas, but I don't know how to execute them perfectly the first time. I could spend hours making crap and wasting resources, and that would be depressing. Best to leave the ideas swirling in my head . . . which is depressing."
- "There are so many *real* artists out there who could do it better; why bother?"
- "Everything I make sucks. I should stop until I come up with something that doesn't suck."
- "I have to get it right in my head first before I commit it to paper."
- "In my head it looks way better than I could *ever* possibly make it."
- "Others can execute my ideas better than I can. I'm not a trained artist."
- "I'm worried that people might not like what I paint; so, why bother?"
- "Because what if this is my last idea, ever?"

BUCKET NO. 2: THE BLAME GAME

- "My Nespresso machine is out of capsules."
- "The cat was sleeping on my sketchbook."
- "My parents think it's too weird."
- "I can't paint while anyone is home; they distract me. Best to wait till the house is quiet; but then, when the house is quiet, I catch up on dishes, etc."
- "A cookie makes a great fall guy, especially when it's already been eaten and can't defend itself."
- "I'm too tired from my day job [child care, any activity]."
- "The cat will not move off the paints."
- "I feel guilty making art when I have so much to do for other people."
- "My iPhone is holding me captive."
- "My kids deserve homemade food more than I deserve to paint for three hours."
- "Because someone outside is playing the bagpipes, and I can't concentrate."
- "My Chihuahua won't get off my lap."
- "Everyone else needs me more."

BUCKET NO. 3:
ENVIRONMENT ISSUES

• "I can't concentrate with my house so messy. Then, after I clean it, I don't want to make another mess."

• "I'll clean up the studio today. Tomorrow I'll do some work. Repeat all the time."

• "I have nowhere to work. My bedroom is too small. The basement is too dark. If I had a room with big windows and light, I would be painting all the time." (I know I'm lying to myself with this excuse.)

• "The light isn't right."

• "I have more paintings than walls."

• "The sun is too bright—which is a pathetic excuse, since all I yearn for is a light-filled studio!"

• "My desk is so messy, I can't find my paints."

• "It's going to be too big, and I don't have room to store it."

• "Almost every day I put off getting started early because it's just too bright in there. Get a window shade? That would be far too easy."

• "This apartment is too small to accomplish anything—I don't have enough space in here! This is typically followed by a mini-tantrum of sorts."

• "I'll start as soon as I get my work space organized. Or painted. Or set up a dream shed with white walls, big windows, lots of shelves, and an espresso machine. It'll also take a while for the honeysuckle to grow around the door frame. But then, there'll be no stopping me!"

BUCKET NO. 4: TIME
(NOT ENOUGH OF IT, WASTING IT)

• "I need more than thirty minutes to make anything worthwhile."

• "I don't have time for the paint to dry."

• "By the time I get to the studio, I'll hardly have time to do anything before I need to go home. I'll just go tomorrow."

• "There's no point in starting now because I'll just have to stop in three hours to go to work."

• "Even if I start something, I won't have time to finish it."

• "It's too late in the day to get started."

• "I need to find that reference. I think I pinned it on Pinterest."

• "I've got to reply to this one last email. Repeat a thousand times."

• "I'll just keep listening to music until the painting comes to me."

• "I need to think it through first. Think a bit more. And more."

• "Gotta sit down with a cup of tea, but there is no milk. Run to the store for milk, oh, and I need eggs, cheese, veggies. . . . Might as well make lunch first."

• "My art supplies are so pretty, so I need to organize them before I start my next piece of art. "

• "Huh? I didn't know I had all of these pencils; I should sharpen all of them. Right now. Meticulously."

• "I put the PRO in procrastination."

Excuses Are the Enemy

Well, that sounds familiar to me (although I don't have a cat—apparently they sit on a lot of supplies). From the black hole that is the Internet, to all of that annoying sunshine streaming through the window—we manage to find the perfect excuse to slam the breaks on our own creativity. I don't love that my readers feel like this, but there is some comfort in knowing that everyone, even professionals, has a list of excuses ready to pull out at a moment's notice. Coming up with a list of elaborate excuses like these takes time, and, actually, a lot of creativity. Just imagine if we gave the same kind of thought and attention to our actual creative endeavors. Who knows what might happen!

ARE YOU SERIOUS?

If you're serious about being a creative person, then be serious about it. Yes, this is the tough-love portion of the book.

You can use day-to-day busyness as an excuse for not living a creative life, or you can take control and *make time*. Don't put your creative life on the back burner when regular life gets busy. It might stay back there for too long, until it evaporates and you're left with a burned pot. Keep it on simmer, and be sure to bring it to a full boil at least once a week. That may mean that you have to schedule your creative time. Okay, not very romantic, but it's more realistic than thinking you'll drop everything the moment inspiration strikes. We all know that rarely works out.

You have to *choose* to make creativity a priority in your life. Here are a few suggestions to help you stay on the path, even when life gets in the way.

Add Creativity to Your Calendar.

Every single day, there will be a thousand things that you feel like you need to do, should be doing, want to do. Sometimes it gets so overwhelming, you think you should just throw in the towel and do nothing. Hello, daytime TV.

When I started writing this book, for example, I was feeling *beyond* overwhelmed. How could I possibly write ten chapters? When would I have time? I'm a full-time graphic designer, and I

have a kid and a husband, and friends, and a house that needs to be cleaned, and a garden that really should get weeded before it completely takes over. *Everything* was my number-one priority; and every time I worked on something other than the book, I felt guilty. And, of course, when I was working on the book, I felt guilty for ignoring all of the other things on my to-do list. I was at the end of my rope. I decided to make a major change: I declared that Thursday would be "book day." That entire day was blocked off for the book, and the book alone. No emailing, no design work, no gardening—our family even made Thursday "takeout night" so that I could work right up until 6 p.m. without having to stop to help make dinner. What a relief.

How can you make creativity your number-one priority, some of the time? If you have a Monday-to-Friday day job and can't declare every Thursday to be your creative day, find another time frame that works. A friend of mine sets her alarm for 5 a.m. (ouch) and makes art until 7:30 a.m., when it's time to get her girls up and out the door to school, and herself off to work. She finds those early, artsy mornings to herself totally invigorating and a wonderful way to kick-start her day. Maybe you carve out Saturday afternoons, with a strategic call to the pizza delivery guy around 7 p.m.—or, if you're really flowing, a bowl of cereal might do the trick! If you can schedule regular meetings at work, and time at the gym, and grocery shopping, then you can schedule this. It may help to delegate some of your other tasks to members of your family. If that's not an option for you, take stock of how you're spending your time. Are there things you can let go of? Could you reduce your screen time to make more room for your art?

Note: Make sure the time you block out for this is actually the time of day when you feel most creative. I've discovered that I don't get into "the zone" until about two o'clock in the afternoon, and then I could go till 2 a.m. So, for me, setting the alarm for 5 a.m. would make no sense. I spend my mornings doing paperwork, running errands, and all of those other excuse-inducing

jobs. Then, at 2 p.m., when my creative fires start burning, I'm ready. Play around with this a little bit until you find your sweet spot—and then *block it off in your calendar!*

Set Deadlines.

So many professional artists, designers, and writers have told me that one of their biggest motivators is a big, fat, juicy deadline. Get out your calendar and mark a big red X on the day that you're going to be finished with whatever it is you really want to finish. If you don't trust yourself to see that through, have a friend or family member give you a deadline, and assign them the task of checking in on you.

Get a Room.

This is one of the biggest complaints/excuses from creative people. "I don't have any room to work." "I have to set up and then clean up every single time I make something." Yes. That can be a huge, annoying problem. There are ways around it, though. Carve out a little corner of one room and set it up so all your essential supplies are within reach. It doesn't need to be large. It helps if you surround yourself with some things that inspire you into action. I actually had a "studio" in a closet once—okay, it was a little cramped, but it did the trick! There are all sorts of space-saver half-tables that get mounted to a wall and fold flat when you're not using them (Google it). And, if you don't have even one corner to spare, then take a look around your town for studio spaces. You can often find shared community spaces that are much more affordable than a private studio. Granted, you'll still have to

convince yourself that it's not too late, or too early, or too dark, or too light to get down there at least once a week! But you know how to handle that now, right?

Form Habits.

Hand-letter a quote from the newspaper every day. Do a photo-a-day project. Take the headline from the top of your local paper, and write one paragraph. Do this at the same time every day.

Committing to these daily habits will accomplish two very important things. First, it makes you incredibly present. As these projects become habits, you'll find that you have started to notice more of the world around you; even your walk to work is a chance to be creative. You'll have to keep your eyes open, because now you're always looking for a bit of inspiration for that day's assignment. Second, these habits make creativity part of your everyday experience. If you do something creative, even a little something, every day, before you know it, you'll be living a truly creative life.

So, what are you waiting for? Start a thirty-day challenge today. And by "today," I mean *today*. Invite a group of friends to do it with you, if you like—it's fun, and it will keep you honest. (See Chapter 8: Failure Leads to Genius—I've given a list of thirty things for you to photograph, or draw, or write about this month. Now you have no excuse not to do it—see, more of that tough love I mentioned earlier.)

Surround Yourself.

Living a creative life also means leaving your studio and experiencing everything that's happening outside of those doors. Going to an art show, the theater, a poetry reading can leave you feeling totally inspired and invigorated. I've broken into a full-on sprint to get back to my studio after attending a beautiful art opening. Go to events, take classes, join creative groups—it sounds time-consuming, but it's also uplifting and is a step toward an enriching, creativity-filled life. While you're out there, look for an exciting chain of events: The more classes and happenings you attend, the larger your circle of creative cohorts becomes. Suddenly, you're not alone in your studio. You're experiencing new things, finding your creative tribe (see Chapter 9: Creating in a Vacuum Sucks), and rushing home inspired to continue making.

Procrastinate with Purpose.

Maybe you're not in the mood to be creative today. All right; but if you're going to procrastinate, procrastinate with purpose! Do something that you might consider creative housekeeping. For example, if my creative mojo has taken the day off, instead of throwing a tantrum and walking away, I start randomly cutting out bits and pieces from all of my thrift-shop books. I have absolutely no intention of making something in this moment. But I know that at some point I will need all of these weird little images perfectly cut, so I may as well get it done. I actually find it relaxing, almost meditative. And the fantastic bonus? It totally gets my creative juices flowing. Suddenly the girl with no plan is clearing the table, grabbing the glue, and making work until the wee hours of the morning! For you, this might be list making, or doodling, or a trip to the art store to grab a few supplies. You see an item or a color that screams your name, inspiration strikes, and new ideas start to flow. Take a moment to figure out how you can procrastinate with purpose. Then, the next time your mojo leaves town, you've got a plan.

NO MORE LIES

Fear of failure, pointing fingers at the people (and pets) in your life, blaming conditions that aren't perfectly perfect, and pro-crastination with a capital P. I've told myself all of sorts of lies. I can't even count how many times I've decided not to start on a project because the light wasn't quite right, or because my studio needed to be rearranged again. What a huge relief to learn that other people also tell themselves these ridiculous, creativity-halting lies.

The secret is out—we've all admitted that we're a bunch of liars. It is officially time to stop making excuses and get on with being creative! The next time you feel you need to alphabetize the complete contents of your studio before you start working, think about this chapter. Remember that excuses are the enemy. Of course you have to make time for your regular life, but you have to make time for your creative life, too. If you tell yourself that being creative isn't that important to you, that's the biggest lie yet.

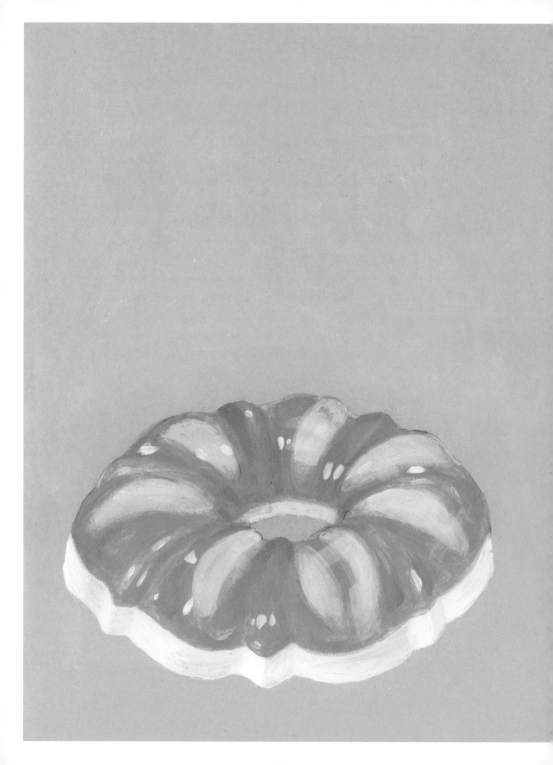

CHAPTER 3: LABELS ARE FOR CANNED PEACHES, NOT PEOPLE

Labels are sticky. They're great for organizing your cupboard; but when people put clingy, hard-to-remove labels on themselves, it can prevent creative growth. And sometimes labels have incorrect information! That's why what's *inside* the can matters. Your inner critic may have slapped on any number of labels: "Imposter," "Just a Mom," "Cubicle-Dweller," "Self-Taught Amateur," "Art School Dropout." It's time to get some warm, soapy water and start peeling those limiting labels off, so that we can see what's actually inside.

WARNING: THIS LABEL MAY STOP YOU BEFORE YOU START.

Before we talk about the contents of the canned goods, let's take a closer look at some of the most common labels. These are a handful of the stickiest culprits who, for some misguided reason, think they get to cover the entire surface of the can. Well, I'm sorry, but labels can't have that kind of real estate. You can be more than one thing at a time! You're not "just" a mom, a student, an accountant, a retired schoolteacher. You're so many things—including creative. Let's take a peek at the fine print:

"I'm a parent."

This is big. But wearing this very important label doesn't mean
that you can't be other things, too. Being a parent can be all-
consuming. It can also be—it *will* also be—exhausting. And when
you're consumed and exhausted, it's likely that your art practice
or even all your creative urges will get pushed to the back burner.
It's difficult to find time and energy for creative pursuits when you
have your parental label on, but you will be a happier parent and
a better one if you give yourself time and space to be a creative
person, too. The key in this situation is speed! You don't have time
for huge creative projects (don't worry, you will again), so finding
quick hits of creativity is what you need. An Instagram a day is a
great place to start, because let's face it, you probably have your
phone out to take zillions of photos of those sweet little faces in
your life. (There is a list of thirty jump-starter ideas in chapter 8
if you need a little help deciding what to photograph each day.)

Another thing that your artist's soul will thank you for: one hour a week that is just for you. Not one hour to catch up on errands, or sleep, but one hour to feed your creative needs. Ask your partner to stay with the kids, or get a sitter. Now *leave* the house! Spend that weekly hour in a place that inspires you creatively: a gallery, a beautiful bookshop, an artsy café, the beach. Bring a notebook and jot down any thoughts that come to mind. As the kids get older, these outings can happen more frequently and last longer. And then, when you emerge from the sleep-deprivation stage, you won't be starting from scratch— you will have enough of these inspiring hours under your belt that when you do have a bit more time, you'll be ready with an entire notebook full of starting points.

"I work in a cubicle."

This just in: You can be a creative person who also works in a cubicle. It's true. All sorts of people have "noncreative desk jobs" and are insanely creative the minute the clock strikes five. Whether you enjoy your day job or not, making time and space to be creative will bring you joy. You are probably tired at the end of a long day, and the weight of your "I work in a cubicle" label may be dragging you down, but it should not be used as an excuse. It's as simple as this: If you want to create, make time to create. Schedule it. Use the program you book meetings with to book creative meetings with yourself. Thirty minutes a day, one hour a day, whatever you can fit into that week. Mark Bradley-Shoup, a practicing artist and lecturer at the University of Tennessee, has some really smart advice for his students who are about to graduate. He tells them that, even once they have a full-time job, they also need to treat their studio practice like a job. It's not frivolous; it's important. He advises them to block off as many hours each week as can fit into their schedules, and then commit to being in the studio for that amount of time. No excuses. You show up on time for your desk job every day, and you need to show up on time for your creative life, too.

"I live in a tiny town."

Hey, me too! And also, who cares? Thanks to the Internet, the world has gotten a whole lot smaller. Publishers in New York can find you through your blog, and galleries in Paris can find you through your Instagram feed. I have to be honest: For a long time, I worried that I wouldn't be taken seriously as an artist or curator unless I lived in a cool loft in Brooklyn. As much as I love New York, that delusional excuse isn't even close to the truth. Can you imagine if every creative person in the world lived on the same corner of the planet? Different places give different perspectives. No matter where you are, own that perspective, and see it as a strength.

"It's too late."

You don't have to drop everything you've been doing for the last however many years, go back to college, write the next great fiction novel or paint a masterpiece for the Louvre by next week. Start by adding thirty minutes of creativity to each day. That may mean one drawing per day, one photo per day, or even plating the perfect meal each evening—whatever it is, make a tiny bit of time for this new creative endeavor. It may lead to an entirely new life that you didn't even know was waiting for you.

"I'm a fraud."

No matter what field you're in, you may feel this way; it doesn't apply only to the creative world. Any time you push yourself to do something new, something out of your comfort zone, you run the risk of feeling like a fraud or an imposter. What if people do find out that you weren't trained at the best culinary school in France? You just happen to be really good at making pastry. And this is not just an issue for self-taught people, either. Someone with a BFA in painting might feel like a giant imposter if he/she decided to take up photography, or wedding planning, or even art curating. I was walking around with a giant "Imposter" label on my forehead when I curated my first few shows. I don't have a PhD in curatorial studies; what if someone found out? They did.

No one cared. I worked hard and loved what I was doing, and, slowly but surely, the imposter label slid right off (maybe it was all the sweat). Ask for help, or fake it till you make it—either way will work. If you love what you're doing, keep doing it. Eventually you'll become an expert.

These are a few of the most common labels that we slap on and may have a hard time seeing beyond; but, as you will see, there is so much more to each of us than these one-liners. Acknowledging, and owning, these labels is the first step in transforming them from creativity-halting excuses into a fascinating part of your unique story: You may be a parent from a small town who is also an insanely talented painter, or a self-taught musician who works in a cubicle by day and plays in blues clubs at night. Decide which part of the fine print you're proud of and which bits are slowing you down. This is a description of you, after all. Make sure that *all* of your information is included and correct.

SCHOOL: TO GO OR NOT TO GO? THAT IS THE QUESTION.

These next two labels are *big*—so big, in fact, that they need their very own section. They are the source of much debate and many unfounded insecurities. Ready?

Self-Taught

Here's a question: How can teaching yourself something new be a bad thing? It shows gumption, drive, and a desire to learn—very admirable! So why do so many people treat "self-taught" like a four-letter word? I've heard very talented people say, "Well, I didn't go to school for this; it's just something I do on the side." So let me get this straight: If it didn't come with a certificate and a gold star, it doesn't count? That makes no sense. It sounds like an inner-criticism to me! Here's the thing, learning can happen anywhere if you are open to it—just look at self-taught greats Paul Gauguin, Vincent van Gogh, Ernest Hemingway, and Prince, to name just a few. It's important to remember that every great, in *every* field, started out knowing absolutely nothing.

Formally Trained

Getting a formal education in something that you're passionate about is an amazing gift to give yourself: years to focus on your work, surrounded by professors and peers to support your learning. Wonderful. But for some people, that diploma on the wall can act as a stop sign, holding them back from trying anything outside of what it says there. This even applies to people with BFAs under their belts. A highly educated, successful painter once told me: "I take photos, but I'm not a photographer—I mean, I didn't go to school for it or anything." If you have always gone the school route, and it's the way you feel most comfortable getting new skills, then embrace that. Sign up for classes, work with mentors, whatever works for you—but don't let that degree on the wall dictate your future.

There are pros and cons to each of these routes. I decided to get insights from two incredibly creative people, whose paths were very different. First, I spoke to Shauna Alterio—an insanely creative artist and designer from Philadelphia. She and her husband, Stephen Loidolt, own a design business called Forage. They met while attending grad school at Cranbrook Academy of Art (coincidentally, the same school where Charles and Ray Eames met). I wanted to know if having an MFA affects the creative life she leads today. This is what Shauna had to say:

Danielle Krysa: What was the best thing that came out of your education?

Shauna Alterio: *Art school is a luxury that affords you time to do a lot of soul-searching guided by mentors and peers. I have a group of girls that I collaborated with while at the Kansas City Art Institute (BFA), and they helped me discover my voice as an artist and a woman. I've had professors that I didn't sync well with, and that struggle developed my determined nature. And then there are the mentors who change the way you see the world. I was lucky enough to have two of them, Francis Resendes and*

Carl Kurtz. They both recognized my crutches, my tricks of the trade, and pushed me outside of my comfort zone in a way that still impacts me today.

DK: What's the most important thing you've learned on your own, after your education, just by being creative every day?

SA: *Just do it. Stop thinking about it, planning for it, and daydreaming. Take action and make your own opportunities.*

DK: Do you have any advice for someone who is considering a BFA/MFA?

SA: *If it's the path for you, I think you know. There's no question, no rationalizing the lifelong debt—it's just what you have to do.*

DK: If you could do it all over again, would you go to art school?

SA: *Yes. Even with 100K in student loan debt, yes! It was my path—it's how I arrived to where I am today. It informed the person I am, my aesthetics, my approach to art and design. It's what I know. That doesn't mean it's the only way. It was just mine.*

"Take action and make your own opportunities." That is some great advice! Now, let's talk to someone with a totally different experience—someone who is self-taught and didn't even pick up a paintbrush until her early thirties. I spoke with artist and illustrator Lisa Congdon:

Danielle Krysa: What did you study in college?

Lisa Congdon: *I studied history, with an emphasis on recent American political history.*

DK: What made you decide to try art? Did you think (or hope) that it would become your career, or was it just for fun?

LC: *I was thirty-one when I first began dabbling in art making, and I did it as a kind of creative outlet outside of my job. I took some classes and really, really enjoyed the process of making art, from start to finish. It was the most satisfying thing I had ever done. However, it was just a hobby for me for about five years—and my work was pretty terrible, at least looking back on it now. During those first few years I never, ever imagined I could sell one*

thing, much less make a living. I look back at that time of my life and think about where I am now, more than a decade later, and it is sort of mind-boggling. But, about five years into it, I started getting inquiries about my work, about the stuff I was posting on Flickr and a blog that I kept at the time. I sold a few things here and there, though I never considered myself an artist. And then in 2005 I booked my first show, and everything changed. It was another five years before it was my full-time income, but that's when it all became a possibility.

DK: What do you wish you'd learned, when you first started making art full-time, that could have saved you a lot of trouble?

LC: *Get out of debt before you quit your day job, and do a good job at keeping your financial books. I know this isn't a sexy answer. But getting your financial ducks in a row is important, and I didn't do it soon enough. I did do it eventually—a few years into my full-time art making. But I wish I had done it before I took the leap and not after. It would have saved me so much grief. It's expensive being a full-time artist. For example, if you are a sole proprietor, you have to pay self-employment tax and you have to pay quarterly taxes based on the money you bring in. The more money you bring in (which is a goal), the more taxes you have to pay. You also have to pay for everything yourself. There is no boss to tell, "I need new paintbrushes." It's sort of like owning your own home compared to renting and having a landlord. Awe-some, yes, but totally filled with responsibilities and expenses. And so not having debt is something I wish I had thought more about before quitting my job.*

DK: How do you feel about being "self-taught"? Have you always felt the same about it, or has your perspective changed over the years?

LC: *I feel totally fine about being self-taught now, but for a long time I didn't. I have embraced my nontraditional path (starting later in life, being self-taught), but at first I felt like an imposter. I have come to learn there is a term for that, Imposter Syndrome, and people from every field experience it. We think that despite our success we are just lucky or that we have deceived*

people somehow to believe our work is worthwhile. I feared I was going to get kicked out of the art club eventually, because I didn't go to RISD [Rhode Island School of Design] or have the right training, and that people would eventually wise up and call me a fraud. I felt like an imposter even after my work became well-known and was selling and I had a long roster of illustration clients. But eventually I wised up, and decided that this way of thinking was not productive and complete bullshit. And I am happy to say I do not feel like an imposter anymore. I value my self-taught-ness now. I see that it has allowed me so much freedom from feeling restricted by or scared of breaking "rules" that exist in the world of art and illustration. It has benefited me greatly!

DK: Have you found any mentors in your self-taught journey?

LC: *There were several people who encouraged me and gave me solid advice early on. My first illustration agent, Lilla Rogers, was one person who really mentored me when I was starting out. She taught me so much about the worlds of licensing and illustration. I will always value what she taught me, and I also value what a wonderful colleague and supporter she continues to*

be. My former studio-mate, painter Jamie Vasta, was also a great mentor to me. She had gone through rigorous art school training and was so knowledgeable about composition and technique and gave useful feedback on my paintings, in particular. She also asked me for feedback on her work, which made me feel so valid in a way no one had ever made me feel before. I owe so much to her as well. There are so many women, in particular, who have gone before me on this path and have been so generous with their time and knowledge.

DK: If you could do it all over again, would you go to art school?

LC: *Art school can be enormously valuable, but my life has been a magical mix of so many different experiences, and mostly I wouldn't trade that for anything. And now, in my forties, I have this thing that I love to do and that I can make a living at. It's given the second half of my life a meaning it wouldn't have had other-wise. Anyone who discovers a new skill or joy or talent later in life should see this as a gift, not a hindrance. So, I think my path was meant to be, just the way it was. Also, it's never too late for me to go back to get my MFA. Though I am not sure I'd ever be able to slow down enough to make that happen! For now, I'm very happy with what I'm doing and very happy with how I got here.*

Shauna and Lisa are both proof that "training" can come from so many different places. If you want to learn something new, go learn something new. Set yourself up to get this new skill in whichever way suits you best. You are what you know, regard-less of when and where you did the learning.

THE SCHOOL OF LIFE

Regardless of whichever path you've chosen, completely self-taught or a formal education, there is a long, exciting road of learning that lies ahead. In the School of Life, there is no exam to pass or fail that deems you CREATIVE or NOT. Not only is there no exam, there is also no template to follow—you have to do what feels right to you, and creating your own path is not only perfectly

acceptable, it's also mandatory. There may not be a detailed map to follow, but there is one very simple, common thread that connects every successful creative person. Hard. Work.

"The only place where success comes before work is in the dictionary."

I love this quote. It's been attributed to many different people, from Mark Twain to football coach Vince Lombardi—but whoever coined it was right. Whichever path you choose, in order to find success you have to work hard, be committed, and never *ever* quit—even when your inner critic tells you to.

FILL THE CAN.

We've removed those sticky, incorrect labels. Now what? Time to look at the contents of this label-free can! Do you know what's in there? Are you a poet? A painter? A dancer? Maybe all of the above? There is a lot of fun in figuring that out. I have an assignment for you:

List five creative activities that you've always wanted to try—things for which you have no formal training. If you're writer, maybe it's painting. If you're a painter, perhaps it's weaving. Pick one and try it within the next seven days. Then repeat with another activity you've always wanted to do, and repeat until you've done all five. It's fine to start small. The Internet is rife with DIYs, training videos, etc. There are so many generous people out there willing to share what they know, so take advantage of that. The next step up from that would be online courses. These range in price and outcome, but there are a lot of them out there and they're worth looking into. (Keep in mind that some trickier mediums will require signing up for an actual, instructor-led course—no self-taught glassblowing please.)

NEW AND IMPROVED!

The old labels are gone, the can is full, and you've started to gather a complete list of ingredients that go into making you the creative person that you are. You now have a brand-new, custom-designed label that you can display proudly as you head down your own creative path. In Chapter 1: Everyone Is Creative, artist Trey Speegle explained how he began owning his creative title. Claiming the title you want (Artist, Writer, Musician, etc.) is a huge first step in living a creative life. Now that you've put on the correct label, own it. Be proud of your contents. During a block, or after getting some unhelpful criticism, you may be tempted to slap that old label back on. Don't. Show people this new and improved version, and let them know that you are so much more than just that old, sticky label.

CHAPTER 4: BLANK PAPER CAN BE BLINDING

Blank paper is so full of hope and excitement! The possibilities are endless. And therein of course lies the problem: The possibilities are endless. What are the rules? There aren't any? Uh-oh. What should you put on that big, perfect, white canvas? Which of your words should be written in that pristine, empty notebook? Even if you have a zillion ideas, getting them out of your head and down onto that precious white space can be insanely intimidating for just about anyone. Luckily, there are many ways to work around that blinding glare. We'll hear perspectives from professional artists about how they stare down the blank page, and, because there is no such thing as too many lists, I've also included a "Top Ten" set of rules for making all of those possibilities a little less daunting.

"White paper intimidates me, and I don't like being intimidated." —Martha Rich

DON'T LET PAPER PUSH YOU AROUND.
I used to fill my studio with perfect white canvases. They were perfect, I was terrified to "ruin" them.

Hey, those weren't cheap, and as soon as you put the first stroke down, you've destroyed their perfectness. You should just give up, before you start. Go on, put that canvas back on the shelf so you don't ruin it with your dumb ideas and obvious lack of painting skills.

Jerk. So I bought a sketchbook instead. I thought I'd paint in that, because there would be less pressure. I chose a gorgeous, red linen–bound book with thick, white paper. It's actually still on my studio shelf, completely blank. Still too precious. Then I discovered the work of American artist Martha Rich. She paints on found bits of paper, and on the pages of old books. Brilliant! The next time I was at my local thrift shop I bought a *Woman's Encyclopedia of Cookery* from 1964 for fifty cents. Suddenly, I wasn't so precious about the pages. If I felt I'd ruined one, I ripped it out and kept going. Sometimes I'd paint around the giant, badly photographed pineapple ham that was featured in the recipe, and make it part of my composition. This new approach gave me a creative, weird, delicious place to start. And these pieces that were meant to be studies actually turned into final works that I framed, hung, and am still proud of today. It was a miracle!

I shared this story with Martha a few years after she had given me that great quote about intimidating white paper. It turned out that, after years of working as a full-time artist, she was no longer bothered by white pages. She told me that she'd become totally comfortable starting a new piece on a clean sheet. I think that's because she now knows who she is as an artist, and what her style is. Also, she's incredibly good at just going for it. She's not "precious" about pieces. If her drawing isn't working, she flips the paper over and tries again. No. Big. Deal. Just as I was starting to feel impressed (and a little bit jealous) that she's managed to get herself to this wondrous place, she added: "Oh, but I would never work on a big, white canvas—now *that* is scary."

EMBRACE CREATIVE POTHOLES.

Naturally, Martha's comment got me thinking about Big White Canvases (BWCs). Let's face it: Their unmarked surface can be very intimidating. What happens if the "wrong" line or splash or stroke finds its way onto that perfection—will it be a disaster of epic proportions? So many people worry about exactly that. What about artists who actually work on BWCs every day? Do they live in a constant state of terror? Fingernails bitten down to the cuticle, night sweats, their inner critic laughing hysterically at their expense? I'm going to assume probably not. I asked one of my favorite abstract painters, Irish artist Lola Donoghue, how she feels about BWCs. Her studio is bursting with giant, perfect, white squares and rectangles, hung on every inch of wall space, as she has several pieces in progress at any one time. That sounds like my nightmare. I asked Lola to share her perspective, and I was totally inspired by her answer:

> "I love a blank canvas. I especially love big, blank canvases. It is my favorite part of the painting process. Once I have stretched and primed a new canvas, I am itching to get at it. It's that lovely moment when I feel so free to paint whatever I like—no constraints or restrictions, not bound by anything. Don't get me wrong: I do have a plan, but it's not set in concrete. My pieces are an emerging process, part planned, part creative accident—abstract work lends itself to this quite nicely.

> "I can begin with a drawing—I use chalk, marker, or anything that comes to hand as a kick-start, then I just go for it, putting as much color and paint onto the canvas as I can. I don't think about what I'm painting at this stage as that can stifle me—it's more about being expressive and the actual act of painting. Something usually unfolds, something accidental, and often this dictates the direction of the piece. It might be totally different than what I had planned—the original ideas or drawings could be completely covered over; and that's okay, I just go

with it. I'm not precious about my work, and often just paint over something entirely and start again on a whim. Yep, Sagittarius!

"My paintings are like a long road trip with many different scenes and moods along the way, and, as on any long trip (in Ireland, at least!), you'll surely hit a pothole or two. This is why I work on about ten canvases at a time. It allows me switch back and forth between pieces. I'll bring a painting to a certain point and when I can go no further, I have others waiting in varying degrees of completion. Drying rates with oils can also dictate the different stages of the piece.

"I am lucky in that I'm a full-time painter, and I can come and go from a piece as I choose. Life gets in the way, too, so I might leave a painting for a few days, or weeks, and then come back to it with fresh eyes. I might decide it's finished, or I might start on it again. I often paint over the part I love the most. That releases me from the ties I had with that particular part of the painting, and, in doing so, renews the creativity. I generally find though, that the bigger the canvas, the better—it's the small ones I find challenging!

"Yes, blank pages can be blinding, but the larger the surface area, the greater the creative rewards when you reveal the hopes and promises hidden underneath. Try it and see!"

Now I want to buy a new stack of big, white canvases. Perhaps this time, I will take Lola's lead and let go a little. Note to self:

- Put lots of marks on the canvas.
- There are no mistakes, just "creative accidents."
- Don't be precious.
- Work on multiple pieces at a time.
- Embrace the occasional pothole.

UGLY IS A PERFECT PLACE TO START.

Clearly, some of us have a fear of big canvases, while others are intimidated by the little ones. Personally, I'm terrified of both, but I'm working on it. One nagging fear seems to be quite common for most creative people as they set out to make something new:

"What if it's bad?"

Yes, what if it *is* bad—on purpose. That's right, face that fear head-on! Go out of your way to make something *really* bad, whether that's a painting, a collage, a short story, or a song. Set out to make the worst painting, collage, story, or song that the world has ever encountered. Why, you ask? I'll let maker, writer, and "ugly" expert Kim Werker tell you. She has mastered, and totally embraced, the idea of purposely making terrible things. I asked Kim to give us a lesson in Ugly 101. Here's her insight:

"We hear so much these days about how valuable failure is, about how we should embrace it as a growth and learning opportunity. And, sure, failure's great, but it's great after the fact (and, let's be totally honest, sometimes it's only great after a decade, or after therapy, or both). Nobody goes into starting a project—whether it's small, like a sketchbook spread or a journal entry, or huge, like writing a book, preparing for a gallery show, or scoring a film—thinking about how valuable it might be to fail. That would be nuts.

"Of course, you can play the mind trickery of telling yourself that the brand-new project will be an amazing experience no matter how it turns out. But that's still an exhausting amount of mind trickery. I know, because that used to be the way I went into a project when I was in a cold sweat, staring at a blank page. I was a master mind-tricker. Not the most impressive skill to boast.

"Now, I just throw one project under the bus right off the bat. I make something that's intentionally ugly. Grotesque, even. Because that's what an epic failure would be, right? So I make something totally revolting,

and then I gloat a little over how capable I am of spectacularly failing, and then I start over, knowing that whatever it is I do from that point forward will have to be better than my ugly thing.

"That knowledge is freeing, my friends. And free is a fabulous way to feel at the very beginning of a project. Give it a shot!"

Simply brilliant. And a ridiculous amount of fun—especially when done with a group of friends on a Friday night with some delicious food, and maybe a glass of wine or two. I highly recommend organizing a group of your friends to try a Bad Art Night (see Chapter 9: Creating in a Vacuum Sucks, about creating your own creative tribe). You'll eat, you'll laugh, you'll intentionally make the worst creation that you possibly can, and, by failing so epically, you'll all win.

DEER IN HEADLIGHTS

The bad work is now out of your system. Huzzah! Wonderful and very liberating. You're inspired, recharged, and officially ready to work on that thing (you know the one)—that thing that you've been thinking about working on for ages. Even though you loved every moment of Bad Art Night, old habits die hard. You may find yourself reaching for a fresh sheet of blank paper. And then staring at it, waiting for a totally original, never-before-seen idea to magically appear. That's a surefire way to set yourself up for an incredibly frustrating afternoon. Here's the thing: Some days the paper is really, really blank. Everyone, and I mean *everyone*, has days when they can't fill the page, and that's absolutely fine. That is not failure, and it's certainly not a reason to quit. It is, however, a reason to look for clever ways to move forward. Here are some ideas.

Rule No. 1: Make Some Rules.

First things first. You need to create a jumping-off point for yourself so that those white pages aren't quite as blinding. (Even that crazy, blank-canvas-loving Lola Donoghue creates a starting point using chalk and markers.)

An easy way to find that starting point is to simply make some rules for yourself. Remember? That was the scary part at the beginning of the chapter—endless possibilities, and no rules in sight. So let's make some. Most of the creative professionals that I've talked to do this for every single project. Their advice—"set constraints and then play within them"—is basically like an assignment in school. When you make rules that you're "not allowed" to break, you can focus—you've got a plan. Here is my top-ten list to get you started:

Top Ten Rules to Play Within

1. Always have a *big* stack of paper. If there's only one perfect surface staring back at you, it instantly becomes *way* too precious; have enough paper that you won't worry about "ruining" it with your words and/or marks. (Your inner critic will have a lot less power against a whole stack of paper. It thrives when you're worried about that one perfect sheet!)

 Note: Be cheap. Make sure that your big stack of paper isn't thick and fancy. Don't buy a beautiful, expensive linen-bound notebook. The pricier the supplies, the more nervous you'll be about what you're doing to them. Grab a pack of printer paper for five dollars, and voilà—no pressure!

2. If clean white paper is too scary, start with a surface that already has something on it, either text or images, and find inspiration or a starting point from what already exists there. Incorporate those words, images, or marks into your new piece.

3. Learn to let go. Chop up an existing image (something you made or a found image), rearrange it, and create a completely new composition. This does two things. First, it removes that whole "precious" issue. The minute the scissors come out, precious goes out the window. Second, you are now free to work with these new pieces in a completely fresh way. This is my go-to activity when I'm feeling stuck, and it works for me almost every time.

4. Choose one color that you love, and then gather all of your supplies (paint, pens, tape, bits of paper) that you own in that particular color. Make something using only those supplies.

5. Pull a sentence from a random place (Twitter, the newspaper, an overheard conversation) and make that the first sentence in your story/poem/song, or make a piece of art inspired by that sentence.

6. Tell your inner critic where to go. On that blank surface, paint or write a message to your inner critic. You can be polite or rude—I usually opt for rude. Now paint over it. Part of your message may show through a little bit, which is great—this is your starting point. It's also strangely comforting knowing that there is a secret message buried underneath your work, a reminder to your inner critic that you're too busy being creative to listen to its nonsense.

7. Collaborate. Ask someone close to you (a friend, a coworker, a kid) to make the first mark. Don't watch or try to control it in any way—just let them scribble, draw an actual object, write a word. Then say thank you, and you take it from there!

8. Flip it around. Forget the white page with a black pen. Use a black page, white pen. Draw the negative space. You're not drawing the vase, you're drawing where the vase *isn't*. Oh hello, back brain, nice to see you!

9. Screw art supplies; head to the grocery store instead. Work on any kind of cheap, readily available surface you can find (paper plates, paper cups, lunch bags) and draw, paint, write on that instead. If it's not a traditional "creative" surface you might be less likely to get tripped up on your usual hang-ups.

10. Cut it down to size. Take one perfect, precious sheet and cut it into twenty-five little bits. Create tiny work on each one, knowing full well that they're too tiny to be considered "final pieces," therefore removing the pressure. I'm sure you'll have a few favorites in the pile of twenty-five. Take those and re-create them on larger sheets (still no need to use fancy paper, though!).

Now you've got at least ten tricks up your sleeve. And the possibilities are still endless, but the difference is, *you're* making the rules. Grab that stack of blank paper, and show it who's boss!

CHAPTER 5: A GREEN EYE IS A GREEN LIGHT

"Comparison is the thief of joy." —Theodore Roosevelt

Jealousy. This is a big topic—it's one of the seven deadly sins, for crying out loud. You may try to run away, but I've learned from experience that jealousy will chase you, breathing down your neck, hot on your heels. The only way to get rid of this toxic emotion is to face it head-on. Yes, stop running and turn around. Stare straight into those big green eyes, show no fear, and then make jealousy work for you.

It's totally normal to be jealous of people who are doing the things that you wish you were doing—believe me, I know. That, however, does not mean you should allow yourself to stew in jealousy for days, or weeks, or years. Take the time to figure out exactly why you're jealous, and this will become your green light to *go* and get things done, turning this negative emotion into something positive. Once you're moving in the right direction, that green-eyed jealousy won't be able to keep up.

JEALOUSY WAS MY GREEN LIGHT.

Before I started The Jealous Curator, I was, well, jealous. I was trying to get back into making art after taking a self-imposed, decade-long hiatus (see Chapter 7: No One Can Wrestle the Pencil Out of Your Hand, for the reason behind that), so naturally

I jumped down the rabbit hole that is the Internet. Did I find artists I liked? Yes: thousands of them. When I discovered work that I loved, I'd have an immediate 50/50 reaction. First, I would be so excited, heart racing, my cheeks flushed with inspiration; I couldn't wait to grab a fresh canvas and get to work. Then, only minutes later, I would feel totally defeated, my inner critic chiming in along the way:

It's all been done in every color. Besides, you could never do it as well as [insert any name here]. Why bother? Let's take a nap instead.

I was bitterly jealous. It was breaking me, and completely stopped me from living the creative life that I so badly wanted to be living. After months of wallowing around in this poison, I'd had enough. It was time to take some control over the situation. I was jealous; but, instead of letting it eat me alive, I decided to stare it down, arm wrestle it, and then flip it on its head.

Within a month or two of writing posts as the Jealous Curator, I was feeling like a totally new person. It was like taking a deep, cleansing exhale. I slowly began to uncover the secrets that would turn my jealousy into admiration, and then I wrote them down.

Say It Out Loud.

It is that simple. Say it out loud. Yes, just tell the person you're jealous of that you're jealous of her or him. Here's why:
• If nothing else, it will make the other person feel great, and that will make you feel good, too.
• Saying it out loud in a positive way, instead of keeping it bottled up inside, transforms jealousy into admiration.
• The person you're jealous of could very well be jealous of you too! Seriously.

I started saying it out loud almost by accident, through the daily posts on my website. By writing about the artwork I loved, I was mastering the first two points without even trying—and it felt amazing. A few months after I launched The Jealous Curator, I decided that I wanted to try one of these "I'm jealous of you" conversations in person. Scary, but it had worked online; why not add a little face-to-face and a fancy latte to the equation?

This experiment took place over coffee on a pretty outside patio. When I confessed my green-eyed jealousy to my coworker, Mary Jo, she was stunned. And then she burst out laughing. She explained she had been jealous of me all this time. It turned out we both had a lot of amazing things going on that neither of us had fully recognized in ourselves. And, with that realization, my wishing days were over; I was ready to be a doer.

Who in your life are you jealous of? Draw these people in closer. Your admiration may convert these talented people from being objects of your envy into your close creative confidants. They may become the ally you reach out to when you're in a creative block or feeling insecure. People you admire are ideal brainstorm partners; wouldn't it be great to get some of their secret sauce in your work? None of this will happen unless you swallow your pride and admit your undying admiration. (See Chapter 9: Creating in a Vacuum Sucks, for more tips on finding your creative tribe.)

Write It Down.

Dear So and So,
Your amazingness drives me nuts, and I'd like to tell you why.

If you're feeling nervous or shy before your confession coffee date, this is a great trick to get your thoughts straight. In some cases, it might be your only option. For example, what if your jealousy alarm is set off by someone you don't know: a friend of a friend of a friend, a celebrity, an artist who died a hundred years ago, or maybe an ex who you *really* don't want to have coffee with. Sometimes, saying it out loud won't work. No problem. Write a letter that you do not send. It's not quite as satisfying, but at least it allows you to articulate what's bothering you. Now, take a look at that letter and grab a fresh sheet of paper, for the next step.

Make an Admiration Action List.

Your action list should be based on the things that make you jealous about a particular person. He or she goes for a run every morning before work. You hate running. Okay, then it's probably not the act of running that makes you jealous, perhaps it's the individual's balanced lifestyle that you want. Put something on your action list that works for *you*: morning meditation, yoga, a walk, the gym. Next: Does the other person make/write one thing every day? If that is something you'd like to be doing too, then pop it onto your list. Break it down, jealous item by jealous item; pin the list up in your studio or put it on your fridge. This is now *your plan.*

Look Behind the Curtain.

The object of your jealousy has a big show opening in New York, or a novel hitting shelves worldwide. What a lucky person. Really? Or did the object of your jealousy wake up every morning at 5 a.m. to work on the project before everyone else in the house got up? Did he or she just get handed this huge show or is it the result of hustling for years—showing paintings on any wall available, from

coffee shops to tiny galleries in the bad part of town? It's easy to be jealous of others' success, and to assume that they miraculously arrived at the top of their field. Look behind the curtain, and take notes. What they *have* is the trigger for your jealousy, but what they *do* may become part of your plan to get on a similar path.

Sometimes the jealousy you feel toward these rock stars in your life comes from insecurity in your own work. But if you don't fear failing (see Chapter 8: Failure Leads to Genius), you can play and experiment until you arrive in a place where you feel confident and proud of yourself. Slowly but surely, you'll begin to let go of that soul-crushing jealousy you feel when you see what other people are making. Sure, there may still be a pang of "Damn, I wish I thought of that"; but now, instead of allowing it to stop you, you can use it to move yourself forward.

Find Inspiration, Avoid Imitation.

When you find a painting, a book, or a song that truly speaks to you, sometimes the knee-jerk reaction is to copy it. "Oh, I love that. I'll make something just like it." Sound familiar? Well, you're not alone; I did this for years. I jumped around, changing my style every time I found work that I loved. I felt like a crazy person with no style or point of view of my own. Finally, about a year before I started The Jealous Curator, I had an idea—a brand-new idea that no one else in the world had ever thought of. I was officially an artistic genius! The idea flashed into my mind one day while playing with my son, who was two at the time. I was an at-home mom. We spent a lot of time "being" dogs, and sheep, and any animal that he decided to be that day. I loved watching him, and so I did a whole series of collages that featured kids' bodies with animal heads. I was so proud of myself. Until I started the blog. Literally on the first day of looking for work to post, I found five artists doing exactly the same thing. Exactly. I was devastated, and frustrated, and strangely jealous of those other artists for think-ing of my brilliant idea before I did. For once I hadn't "copied," but I might as well have. Damn. Back to the drawing board. In fact, getting shoved back to the drawing board was actually a creative blessing. This little animal-head fiasco challenged me to think about what I was trying to articulate. Was there another way I could visually represent that idea? Of course there was. I just needed to get into the studio and push myself past the first idea.

There I was, genuinely believing that I was the first person to put animal heads on kids, while I'm quite sure those other five artists thought that they were geniuses too. The bizarre thing is, often there's just something collective going on in the universe. Geometrics are trendy, flowers have been a go-to subject matter for centuries, and there might just be more than one novel about vampires. As for collage work, it has a very unique issue all its own: A lot of collage artists use the same vintage images, not because they're "stealing" from each other, but because of copy-right guidelines. The result is that these artists end up using

images from the same time period (*National Geographic* 1950, anyone?), so their final pieces will look similar.

In any creative discipline, it's wonderful to be inspired by others. How sad would it be if you weren't? But then it's your job to alter, remix, combine, transform, and challenge yourself to make those found images, floral still-life paintings, and vampire stories into something unique. You'll find yourself creating work that is influenced by the world around you, but that is truly your own.

YOUR GREEN-LIGHT ASSIGNMENT

As you were reading this chapter, who popped into your mind? Was it other creative people? A superstar at your office? A "perfect" mom at the park? It doesn't matter who you're jealous of, or why. What matters is that you find a way to turn that toxic flow of jealousy into something positive. Write down those names, the reasons why you're jealous, and then start setting up the coffee dates (or writing letters). Be open and honest, and buckle up: Your stop light is about to turn green.

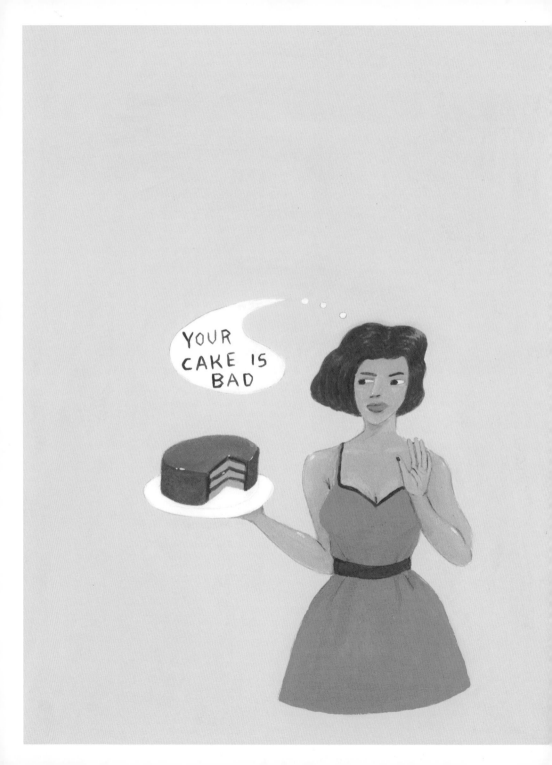

CHAPTER 6: YOUR INNER CRITIC IS A BIG JERK

Oh, that voice—it is the root of so much trouble. It shows up with cruel comments, snarky jabs, and is always armed with a long list of reasons and excuses for quitting. It prevents talented people from doing amazing things, often stopping the flow of creativity before it even starts. It sits on your shoulder whispering hurtful words that plant the poisonous seeds of self-doubt. What a jerk that inner critic is. But wait, I have good news. Your inner critic isn't in charge; you are. You can quiet that voice, and even bury the hatchet, turning that manipulative jerk into a trusted ally, with just a bit of effort—okay, maybe a lot of effort. We'd better get started.

AN INVESTIGATIVE ASSIGNMENT

First things first. Where did this annoying voice come from? It certainly wasn't there when you were glitter-gluing feathers and macaroni onto colored sheets of paper. When, how, and why did that inner critic's voice show up? It's time to launch an investigation.

Step One: Identify "The Voice."

Do you know who your inner critic sounds like? Is it the voice of an unsupportive teacher from your past? A parent who didn't encourage a creative path? A professional critic who panned your work? The first step in silencing this voice is to recognize where

it originated. It's important to acknowledge that this voice is not *part* of you. It's a collection of negative words and experiences that derive from external sources. That voice doesn't belong in your head, unless it can learn to support you.

Step Two: Pinpoint the Attack.

What, and when, is your inner critic attacking? Does it pop up only when you're writing? Maybe it's quiet when you're cooking a gourmet meal, but shows up when you paint. Unless you pay attention to this, it may feel like your inner critic is there 24/7, but I can almost guarantee that that's not the case. It preys on insecurity. When you're doing things that you enjoy, creative endeavors that come easily to you, that little voice slinks off to sulk in the corner. Take note of those moments, and bookmark them—we're going to come back to this.

Step Three: Unmask the Guilt.

Inner critics can sneak into your life in the form of guilt: parent guilt, family guilt, work guilt. This guilt convinces you that creative pursuits are frivolous and that focusing on them is a waste of time. Your inner critic flourishes in that guilt-filled environment— it's like mold thriving in a damp, warm room. Just imagine if everyone fell victim to this. What if Leonardo da Vinci had felt like painting the *Mona Lisa* was a waste of time, or if J. K. Rowling had allowed "mom guilt" to stop her from writing the Harry Potter books? When you unmask that guilt, guess who you'll find? Yes, it's your inner critic hiding back there! Sneaky jerk.

The sooner you do this investigation, the better. Once the mystery is solved, you'll be that much closer to silencing that unhelpful little voice. In fact, just acknowledging that you have an inner critic, and understanding where it comes from, takes some of its power away. You can gather up its nasty comments and dismiss them, instead of believing them as truths. Soon, you'll begin to realize that they're just a collection of fear-based words coming from an insecure bully.

STAND UP FOR YOURSELF.

Speaking of bullies, here's an interesting experiment: Write down one of your inner critic's usual jabs. Go ahead, do it right there in the margin of this book. Mine usually says something like,

You're such an amateur, and if you actually make work, people are going to find out that you have no idea what you're doing.

Yes, something wonderful like that. Write yours down and then read it out loud, at full volume. Now, let me ask you this— would you ever, *ever* say these words to someone else? A friend, a colleague, a student, a child? No, of course not; so why on earth do we speak to ourselves in such a harsh, abusive way? In fact, if you overheard someone say this to your friend, you'd jump immediately to their defense.

This, my friends, is a major case of bullying. Each and every one of us should be carrying signs, marching in a circle, and chanting, "No to bullying" (I can see the T-shirts already). So, the next time your inner critic has something to say, pay attention. If it's a statement that you would never, *ever* think of saying to another human being, then jump in and defend *yourself*! Wash that bully's mouth out with soap, and send it packing.

EXPERTS HAVE IT ALL—INCLUDING SELF-DOUBT.

It's hard to believe, but even people at the top of their creative game have inner critics, and the occasional bout of self-doubt. It seems like professional artists, authors, and musicians must have it made: They're living the dream. Surely they would never spend a moment second-guessing their creative choices. But they do.

When I interviewed the fifty visual artists in my first book, *Creative Block*, one of the questions I asked was, "Do you ever hear your inner critic?" I actually hesitated to send that question, because *my* inner critic told me that these very accomplished artists would respond with: "My what? No, I don't have that . . . you amateur." Well, I'm glad I ignored that negative opinion and asked them anyway. All of the artists confirmed that they do, in fact, hear little whispers in their ear all the time. However, what makes these professionals excel is that they do not allow those whispers to stop them from leading a creative life. Yes, they may have an inner critic, and the occasional bout of self-doubt, but they *also* have:

Dedication. They keep making, whether their work ends up on the gallery wall, on the stage, in a novel—or in the garbage bin. They continue to create, every single day.

Time. They make space and time to be creative. They don't put their work at the bottom of their priority list. Being creative is their priority.

Trust. A lot of successful professionals trust that little voice. When it speaks up, they know that they're probably heading down the wrong road. Over years of working together, they've become friends, friends who disagree from time to time, but ultimately they have the same goal: great work!

THE SILVER LINING

As much as I hate to admit it, even jerks are right sometimes—granted, they could find a more constructive way to deliver the message. In order to get back in the driver's seat you'll have to hone your translation skills. Once you actually know what your inner critic is trying to say, you can decide what to do with that information. Here are a few things to consider.

GRAIN
O'
SALT

Take It with a Grain of Salt.

In most cases, bedside manner is not a strong suit of the inner critic. It *might* be telling the truth, but, because the message is being delivered by a jerk, it's *really* hard to listen to. Giving up, throwing your work away, and eating junk food sounds like a much better idea. But don't do that. Take a deep breath, weed through the junk, and then translate those harsh words. Is there some truth there? Even just a little nugget? Maybe. For example, if you hear, "Um, how many unrelated images can one person put on a collage? Have you ever heard of editing?!" True, perhaps you did get a little carried away. Take that feedback and translate it into something that's actually helpful and proactive, such as: "Hmm, this feels a bit busy. Here's an idea: Slice this up into several small pieces and make a whole series of simple collages from each strip." There, now *you're* in charge. You've distilled the message and you can take it at face value. Then it's your call if you want to apply it to your work or not.

Explore a Different Angle.

Perhaps what your inner critic is trying to tell you is that the problem is the format, not the medium. Are you trying to write a huge novel, but find it overwhelming? Maybe you should start an anonymous Twitter account and write in 140 characters for a while. If painting on canvas isn't working for you, don't quit painting. Just try changing your surface; give vintage found paper a shot. Just keep going, even if it's in a slightly new direction.

Discover a New Path.

This goes hand in hand with step two in our investigation from the beginning of this chapter—pinpointing the attack! Pay attention to when your inner critic has something to say. For example, I have almost no insecurities when it comes to my blog, and all things "Jealous Curator." I'm proud of myself, never second-guess my choices, and almost never hear a peep from that little voice. As a collage artist, I hear it only from time to time, and I can usually work past the rude comments. But when I try to paint—well, the only thing I can hear is, "You should never paint again." Maybe you don't hear anything when you're drawing, but you hear it while writing. Perhaps you can play an entire guitar solo without one whisper, but it screams if you try to sing. We often discount the skills that come easily to us (they don't count because we're not suffering? Artists are supposed to suffer for their craft, after all!). On the other hand, perhaps your inner critic has a point. Forcing yourself down a path that you're not enjoying, just to prove that you can do it, isn't a great idea. Of course, keep working on new skills that you want to conquer. And if you can begin to trust that voice, you might just turn a creative corner. A wise man once said:

**"Everybody is a genius. But if you judge a fish by its ability to climb a tree, it will live its whole life believing that it is stupid."
—Albert Einstein**

As a painter, I felt like that fish trying to climb a tree, but, the minute I embraced being a collage artist—because I'm actually good at it, and genuinely love creating this way—I felt like I was set free to swim (see Chapter 8: Failure Leads to Genius). If you listen carefully, and do a bit of translating, your inner critic might just nudge (or shove) you down a new path, and then you can finally get on with the business of being a genius.

TURN THE CRITIC INTO A CHEERLEADER.

Why doesn't that little voice ever pipe up when you're succeed-ing? What about a nice, *"Hey, way to go! You proved me wrong!"* Nope. Just silence from the peanut gallery . . . until you're work-ing on something new, and then that voice shows up again. Why can't it say, "You're going to knock this one out of the park just like last time, you superstar!"—instead it comes back with, *"Well sure that last thing was okay, but what are the chances you can pull that off twice?"*

This voice is incredibly influential. But why is its great power only used for evil? Let's flip this whole thing around, like a fancy back handspring, and make that voice cheer for us instead!

Give It a New Name.

Confession: I actually, *really* don't like the term *inner critic*, even though it's on the cover of this book. It feels almost impossible to turn a phrase that is 50 percent "critic" into anything remotely warm and fuzzy. I've heard other people refer to their inner critic as "Mini Me," "that voice," "the opponent," and a few things that we'd have to bleep out. But my absolute favorite name came from a young writer who I recently met. He calls his inner critic "Arlo." I want an inner critic named Arlo! Sure, Arlo might have a bad day from time to time, but I feel like we'd have a better shot at being friends than me and my "inner critic." Do you already have another name for yours? If not, give this rebranding exercise a try.

Rewrite the Script.

When you are working, or thinking about working, and your inner critic pipes up with something mean, negative, or annoying, *stop* what you're doing and write those words down. Right below that, flip the statement around, and write the positive opposite of whatever your inner critic just said. Read it out loud, at full volume. Make a conscious choice to listen to that comment instead. You can even hand-letter or collage a few of the best ones, and pin them to your wall. After a few months, you'll have a studio full of lovely, encouraging works—which are great to read on the days when Arlo is in a bad mood!

Prove It Wrong.

That little voice says you can't paint? Do a few quick, fun painting assignments. They may not be ready for the walls of MoMA, but you did in fact paint! It said you couldn't, but you just did. Do it again, and again, and again until it starts to believe in you.

Talk About Pros, Not Cons.

Not long ago, I was teaching a workshop at a high school arts festival. I asked the entire group, kids aged fourteen to eighteen, if they knew what I meant by "inner critic." Unfortunately, they all knew exactly what I meant. During the break, a very kind, smart, and thoughtful seventeen-year-old named Lucas asked if he could talk to me about his inner critic. Lucas had just finished writing a play, one that he had worked on for ages, and was proud of. Wonderful, right? But he told me that his inner critic made sure that Lucas recited a detailed list of everything that wasn't quite right, before he handed the pages to anyone to read. "I would much rather be on the winning team," Lucas told me. Winning team? I was confused. "Yeah, I want to be teamed up with the person I'm showing my play to—both of us united against the work." Apparently the "losing team" was Lucas and his play—the play he was proud of. He would rather throw his play under the bus than stand beside it, for fear of getting run over, too. We both agreed that he, and his play, didn't deserve this. Nor does anyone's work.

So many people create this list of negatives, disclaimers, or excuses when sharing their work, as if to create a magical, protective shield against criticism. Why introduce these negative ideas into the recipient's otherwise open, objective mind? Instead of spending precious time preparing a mental list of everything that you're *not* happy about, come up with a list of things you *love* about this work. Granted, in your mind, the work might not be perfect, and there may be a version 2.0 in your future; but be proud, and acknowledge the parts that you really love. That puts you and your work on the "winning team," and throws your inner critic under the bus all alone.

Say Thank You.
Never speak badly of your own work (remember, say "No to bullying"). When someone compliments you, say thank you, even if, like Lucas, you secretly want to give them an itemized list of flaws. For example, if a friend says, "I love that drawing," and you respond with, "Well, I don't love that top part, and I didn't have the kind of pencil I really wanted to use, and it should probably be a bit bigger," your inner critic will be in heaven—rolling around and basking in all of the negativity. To thwart your inner critic, just smile, say thank you, and practice being proud of yourself— even if you're totally faking it! Your inner critic will be so confused by this new behavior, it might just hop on the bandwagon and start cheering, right along with everyone else.

A NEW FRIEND?

Okay, calling your inner critic a "friend" might be pushing it at this stage, but you can transform that voice into a trusted truth-teller and ally whose advice is worth listening to. Take it or leave it, trust it or not, but if you want to be in charge, there is only one thing you need to remember—*do not quit*. A real friend, one who's worth trusting, would *never* tell you to give up on your creative dreams.

CHAPTER 7: NO ONE CAN WRESTLE THE PENCIL OUT OF YOUR HAND

Criticism: the act of passing severe judgment; censure; faultfinding. —Dictionary.com

Ouch. That doesn't sound good at all. Now, just to be totally clear, there *is* good criticism. Really. When it's constructive, and comes from a kind and trusted source, feedback is one of the most valuable things you can be given as a creative person. What I'm talking about here is the hurtful and harsh kind of criticism that stops you in your tracks and does nothing but damage. That kind of criticism sucks.

"ME TOO" STORIES

I used to believe that I was one of the few to be bashed down and stopped by criticism. I have learned that is definitely not the case. When talking to people about my book *Creative Block*, I was stunned by how many "me too" stories I heard. Some starred actual professional critics, but the majority of "stick in your head forever" tales were filled with very harsh words from trusted sources like parents and teachers. I cannot emphasize enough

how important both parents and teachers are in fostering creative self-esteem—or its opposite. Constructive criticism at the right moment can fuel someone to become better, stronger, and more successful. Negative criticism at just the wrong moment, on the other hand, can have a lifelong negative effect on how people see themselves creatively. In Chapter 1: Everyone Is Creative, we talked about the telling response: "Me? No, I'm not creative." This is probably exactly where that comes from.

Whether criticism comes from teachers, parents, friends, coworkers, or actual professional critics, it can knock you down and stop you forever. But it doesn't have to. You can get back up, dust yourself off, and keep going. I have gathered stories from some very creative people who have done exactly that. And because it would be a totally chicken-out move for me not to tell my own story, that's where I'll start.

MY STORY

I was the art kid. I painted, sewed, wrote stories, put on plays, and glued beads on everything. I entered every coloring contest I could find, and in high school I was the art coordinator for the yearbook. That said, I also liked science. My mom is an artist, and my dad is a PhD-wielding scientist, so I had both influences in my life. When it came time for university, after much internal debate, I decided to study marine biology. It felt more responsible than going into art. I wasn't completely confident that my love for art could be anything more than a passionate hobby—a very common but not necessarily valid misconception (see Chapter 2: Excuses Are the Enemy).

Near the end of my first year, my dad said, "I think you should switch into fine arts. It's who you are. It's who you've always been." When I asked him how he thought I might pay for things like food and rent, he very calmly said, "Do what you love, and the money will come. And if it doesn't, you won't care, because you'll be happy." Pretty amazing. I listened. With excitement and a touch of nervousness, I switched into the BFA visual arts program.

Imagine, then, the art kid's surprise when she did not fit in at art school. At all. For the next three years I did my best, but I felt very alone. I struggled with, well, everything. I got fairly used to getting bashed in critiques and was definitely developing a thicker skin—ultimately a good thing, I suppose. Yet not thick enough for the critique that came six weeks before I graduated as a painting major.

I had been working on a series for my final show and it was my turn to share my work with the class. I prepared myself for the usual bashing. But my professor (let's call him "Joe"), who usually hated everything I did, loved my work. Huh? He went on and on about how I'd "found a new niche," how he hadn't seen anything like this before. At the end of that class, he told us that an artist from New York would be visiting our studio the following week, and that three people could show their work. Everyone sat quietly, nervous about voluntarily putting their work in front

No One Can Wrestle the Pencil Out of Your Hand

of a "real artist." Not I—I raised my hand immediately. Why not? I'd just had the best critique of my life.

I put up the same five pieces I'd shown the week before, and then got ready for what was meant to be a ten-minute discussion. Thirty very long minutes later, I sat stunned and red-cheeked, as my entire class tore the work apart—my professor leading the pack. He actually said, and I quote, "You should never paint again." I was so confused. Normally I could defend my work, but I was just so blindsided by how radically my teacher had changed his tune that I couldn't even speak. I could feel the hot tears perched just behind my eyelids, ready to stream down my face the moment the first word left my mouth. I was already so embarrassed in front of the visiting artist—I certainly didn't want to cry in front of him as well! He was incredibly kind though, and moved his chair from across the room to right beside mine. He gave me a quick wink of support, but by that point the damage was done.

I had so many projects to finish before the final graduation show and the only thing I could hear was, "You should never paint again." I second-guessed every stroke, every idea, every single little thing. I graduated, but I felt broken.

I tried to keep making art, but I could never quiet that voice—that voice that slowly, over time, became my jerk of an inner critic. It would be almost fifteen years before I felt confident enough to make fine art, let alone show it to anyone. But I did—and, if you look at the positive side of this story, I actually have that teacher to thank for a big part of the success I've had in recent years. If not for that very defining moment early in my art career, I never would have had the need to start The Jealous Curator. So, thanks for everything, "Joe." I couldn't have done it without you.

Now, this is not just an "art" thing—it's a creativity thing. I have talked to many visual artists about their crushing criticism stories, but I've also found myself in conversations with actors, designers, and writers—and their stories are exactly the same. When I decided to write this book, and this chapter in particular, I just knew I had to reach out to some of those people and ask if they'd be comfortable sharing their "me too" stories. All of them jumped at the chance to share their tales of crushing criticism: how it knocked them down, and how they picked themselves back up.

The first story I want to share is shockingly similar to my own. It takes place in the theater department at UCLA over a decade ago:

Autumn Reeser, Actor (*The O.C., Entourage, Hawaii Five-0*)

"*I started theater school from a very different place than most of my classmates. In high school, I had been all about exter-nal achievements ('Type A' and 'teacher's pet' were good words for me) and most of my college classmates were from the 'darker' side of high school—the misfits, goths, geeks, and artists. I des-perately longed to feel like one of them, and ultimately college brought me the necessary moments of 'being an outcast' (or at least feeling like one) that are often essential to life as an artist.*

I pushed myself further and further artistically, but oftentimes it was just too much, and I was left in a puddle of tears from the sheer effort, emotion, and loneliness of it all.

"My most conscious moment of facing this was during rehearsals for a play titled Tell Me the Truth About Love. *I must have been having a difficult day of it, because during rehearsal, when the time came for my solo, I couldn't open my mouth—I burst into tears instead. Terribly embarrassed in front of my hyper-talented and cynical classmates, I ran offstage to catch my breath and collect myself. Seconds later, I was followed by our director, a man in his sixties who was not particularly suited to the challenges of instructing budding young adults. He cornered me and, for the rest of my classmates to hear, screamed at me about how a professional would never do such a thing, and how I would never make it in the theater world without a thick skin. I responded by sobbing harder. I never was able to make it back onto the stage that day. I still have a sinking feeling in the pit of my stomach when I remember that show, but, even though I couldn't make it back onto the stage that day . . . the next day I did. And the day after that. And the day after that. I faced my embarrassment, I nailed the solo in the show, and I proved to myself that I couldn't be intimidated. I was a dedicated, reliable, and talented performer. And, despite the director's crushing words, I* did *become a professional actor.*

"There's a saying in the acting world: 'An actor must have the skin of an elephant and the soul of a rose.' I think that's good advice for any creative person. Developing a thick skin is not about crushing that part of you that is sensitive and open to the world—that's the part that makes you need to create. But what defines that "thick skin" and makes you a professional is your ability to keep putting yourself out there in spite of the inevitable rejection, embarrassment, and moments of feeling out-of-place. All you can do is walk back out there the next day. And the day after that. And the day after that."

It's crazy how close Autumn's story is to mine. A painter and an actor. How about a designer? And, just to shake things up even more, this story didn't happen in a classroom fifteen years ago. This is the criticism that stylist/interior designer Emily Henderson is facing today, online:

Emily Henderson, Stylist/Designer/Blogger

"Most days I get three kinds of criticism, from three kinds of people—'the angry,' 'the jealous,' and 'the disappointed.'

"'The angry' write me emails saying, 'You may as well throw shit on the walls and call it design. What you do, my two-year-old could do. You are a piece of shit and you should quit or kill yourself.' I don't get those very often, thank goodness. Those comments are disturbing because it's always jarring to know that what I do (design, not politics! not religion!) is the victim of some-one else's total unhappiness and self-hatred. It doesn't make me question my work, it makes me buy a security system for my house. I'm not kidding.

"'The jealous' troll on sites with lots of 'Ugh, if I have to see one more pic of her fat baby, I'll stab my eyes out,' or, 'Look how perfect her life looks with her perfect baby and it's totally obvi-ous her husband is gay, ugh.' Let's face it: Anything involving my children pisses me off, but the sentiment is more that they see me happy, possibly happier than I used to be, clearly happier than they are, and they are envious of said happiness. Fine.

"The worst of all criticism is from 'the disappointed'—from the people who used to be fans, who used to follow my work and read every day, but have stopped. As I've gotten more successful and the blog has gotten bigger, they feel I've changed. And they aren't wrong. That's why it stings, and exactly why it's helpful.

"Those disappointed fans—and there were a lot of them— made me so sad, embarrassed, ashamed (and then mad that I was forced to feel ashamed of my own happiness); and ultimately led me to take a step back, pretend I was a reader, and adjust.

"If you have a point of view and success, you will have haters. Congratulations. But when the people that are hating on you are exactly the same people that helped grow your success from the beginning—and they are consistently all saying the same thing over and over—then you better perk up, listen, and make some changes. Success clouds your brain and makes it easy for you to think that everyone will love you no matter what, that you have thousands of cheerleaders in your pocket all the time. You don't. You have to try every day to be better, to create more, succeed harder, improve, and impress yourself and others."

"Perk up, listen, and make some changes." This is one of the reasons why I admire Emily so much. That stinging, burning criticism that made her sad didn't stop her. Because when you trust the source of your criticism, you should listen, adjust, and move forward.

Finally, because these stories are just too good not to share, I've asked two incredibly accomplished visual artists to relive their very defining encounters with criticism:

Anthony Zinonos, Illustrator/Collage Artist

"'You have poor drawing skills.'

"Those crushing words came out of a tall, bearlike tutor who seemed like he would have been more at home working as a football coach or a lumberjack hacking down trees all day, not dealing with overly sensitive eighteen-year-old art students who each had dreams of becoming the next Picasso.

"It was the matter-of-fact way that he said it that really struck me, as if he were just stating the obvious, like, 'You are wearing black shoes.' Needless to say, those words ended my drawing career. Just hearing the phrase 'life-drawing class' made me break out in a cold sweat.

"Thinking about it now, though, if not for that tutor, I would not have pursued photography and collage so intensely, leading me to my career today. So I'd like to thank you, 'The Bear' (what I and the other students used to call him, and whose real name I seem to have selectively blocked out). Your words might have been harsh and soul-crushing at the time but now, fifteen years later, I can fully appreciate your criticism and push into the right direction."

Martha Rich, Artist/Teacher

"When I was heading off to college at eighteen, I had a vague idea that I would study art. I was lucky enough to have gone to a high school that had an 'art major' and so it made sense to continue studying art at the liberal arts college where I had been accepted. The college wasn't known for its arts program. I had picked that college mostly because of the cute guys playing Frisbee on the quad.

"When I went off to college, my mom was battling cancer and had been since I was sixteen. I was pretty aimless and sensitive and going through the motions of what you are 'supposed' to do at this time in your life. So I took all the required 101 classes, including drawing. That drawing class was a struggle for me. The teacher told me I couldn't draw, and I believed him. In my fragile state of mind, I quit art altogether, and graduated with a degree in Sociology/Anthropology.

"I didn't make art again until I was thirty-five and going through a divorce. A traumatic experience took me away from art, and another brought me back. Art is in me; I couldn't keep it buried. Something was missing, so, to cope with the divorce, I decided to take an illustration class. The rest is history."

TURN CRITICISM INTO CREATIVE FUEL.

In all of these stories, there is a common thread: If you don't allow the knock-you-on-your-ass criticism to stop you, you can actually use it as fuel to propel yourself forward. Hopefully it won't take years for that forward movement to kick in! Ultimately all five of us can now say, "Thank you, harsh critics. If it weren't for you and your jarring words, I never would have found this new path." Or something a little less polite than that.

Now, even if you're able to triumph over your own "Bear," it most likely won't be the last battle you'll fight. You'll run into more criticism along the way, but you will be ready. Slowly but surely, you'll get better at taking mean-spirited criticism with a grain of salt, and will learn to embrace it when it's actually helpful. Like dealing with your inner critic, you should take whatever you can from the criticism that makes sense to you, ignore the bits that had absolutely no value, and then move on. Easier said than done, I know, but here are a few of my best tips for turning criticism into creative fuel.

Put the Gloves Down.

It's human nature: The moment you get feedback that you don't want, your defenses go up. But put the gloves down long enough to listen, and there might be some valuable gems for you there. Is there any truth to the criticism? Even just a nagging little bit that you might agree with—and perhaps that's why you're defending that choice so ferociously. (There's a theory that the people we dislike the most are often those who display the traits we dislike in ourselves. It can be the same with blunt criticism.) Let your guard down for just a minute. Listen carefully for the truths. If there are any, take them and move on—swiftly!

Say It Out Loud.

As we've noted, many of us are ashamed of these stories, and so we just tuck them away, where they repeat inside our heads. Negative criticism has power in there, but *you* can take that power away. Share your story with someone you trust—a friend, your mom, a like-minded studio mate. As soon as you say it out loud, it's not nearly as upsetting, and you might even find a bit of humor in it. Or not. But at least now you've got one more person in your corner, making sure that you don't quit.

Criticism of Your Work Is *Not* Criticism of You.

Put that up on your fridge so you don't forget! I know, it's very easy to equate yourself with your work, but when someone gives feedback, whether helpful or harsh, it's not a comment on you as a person. It's simply someone's subjective opinion on a painting or a performance or a chunk of writing. And since there is so much more to you than that piece of work, you can't possibly take it personally, right?

Click Delete.

Ah, the Internet. A vast source of cruel, faceless criticism from people who would never have the courage to say such things to your face, yet a comment field allows them to run wild. You want to defend yourself, to fight back against that faceless critic as you read his mean words at 2 a.m. Don't. Just click delete. Do it. There is no point in engaging. In fact, that's often what these cowards are looking for—a bit of entertainment at your expense. They don't deserve your time. They deserve the delete button.

Pick Up Your Pencil.

These wise words are one of my favorite bits of advice on negative criticism. They come from Canadian painter/designer Amanda Happé:

"No one can wrestle the pencil out of your hand. You get to keep going in absolute defiance."

Brilliant, and oh so true. The first time I read this (it was one of her answers to my *Creative Block* interview), my heart skipped a beat. I immediately thought about that very defining critique in my last year of university, and suddenly had a major aha moment. I had always blamed my professor for the drastic halt in my artistic life. But *he* didn't put my pencil down. I did. It was my responsibility to pick it back up. Don't let anyone else put your pencil down. Keep going, in absolute defiance.

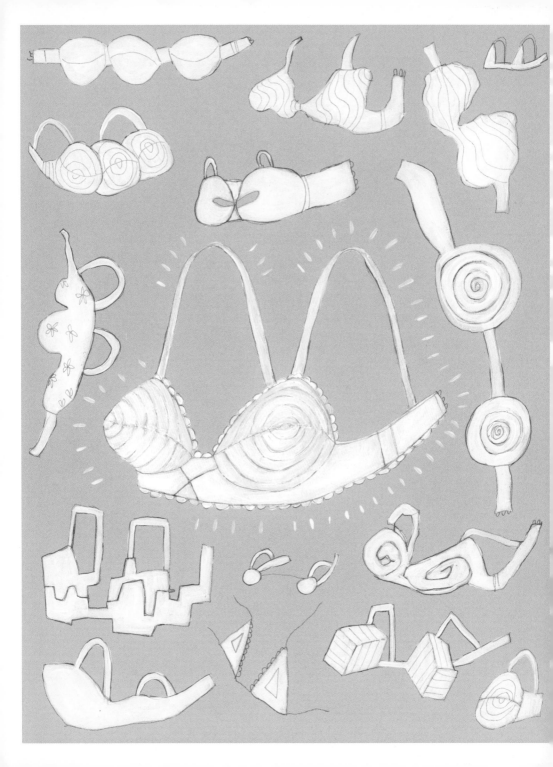

CHAPTER 8: FAILURE LEADS TO GENIUS

When I started writing this book, I was frozen with fear, in a full-on panic attack. I was absolutely terrified to fail. And then a wonderful friend sent me this quote:

"An artist cannot fail; it is a success to be one." —Charles Horton Cooley

So true, Charles, so true. I had already succeeded just by showing up at my keyboard. Failing would be letting the fear win, closing my laptop, and walking away. I wasn't going to do that, so technically failure wasn't even a possibility.

Quitting something that you're passionate about—or being too scared to start it—is the only way that we can define failure. Everything else, all those crumpled papers on the floor, is not failure; it is a beginning. A whole floor *full* of beginnings, in fact. Those papers are experiments, in-progress ideas, exciting mistakes that might just be on their way to something brilliant. Thomas Edison created 10,000 prototypes of the lightbulb before he got it right; but if he'd thrown his hands up and quit at prototype number 9,999, he would have failed. The moral of the story: Keep going! Explore, make mistakes, play some more, make more mistakes, learn, and enjoy every moment of your wonderful, imperfect creative journey. In this chapter, you'll get some fuel to keep your engine humming.

QUOTE OF THE DAY

Charles Horton Cooley's inspiring quote is among literally hundreds of well-known quotes about how to put failure into perspective. You've probably even recited at least one of them at some point. It's great that so many clever people want us to know that we can overcome failure. However, these very insightful words have been so overquoted, and so widely shared all over the Internet, that they've become pop-culture wallpaper that we barely even notice anymore. They're something you scroll past on Pinterest while you're looking for cool tattoo ideas. Okay, yes, I might have been looking for cool tattoo ideas when I stumbled across this one:

"Failure is a bruise, not a tattoo." —Jon Sinclair

Normally I would have glanced right over this beautifully typeset quote and continued scrolling, but this time—because I was writing this chapter, and failure was top-of-mind—it stopped me in my tracks. I actually read it. It's brilliant and true! Failure is a momentary setback, just a bruise, that absolutely does not have to affect you for the rest of your life. Obviously, I immediately changed my search from "tattoos" to "inspirational quotes, failure," and away I went. I found a ridiculous number of very smart sayings—and, it turns out, they're even more impactful when you actually read them. Who knew? Now you have to promise me that you won't skim over this little list of inspirational wisdom. I've gathered quotes from van Gogh to Winston Churchill, and, with a range like that, you know it will be good! Put these up on your wall, and on the days when you feel like quitting, read them— *actually* read them:

"The master has failed more times than the beginner has ever tried." —Stephen McCranie

"I have not failed, I have just found 10,000 ways that don't work." —Thomas Edison

"Failure is the condiment that gives success its flavor." —Truman Capote

"Success is not final, failure is not fatal: it is the courage to continue that counts." —Winston Churchill

"There is no innovation and creativity without failure. Period." —Brené Brown

"Success is sometimes the outcome of a whole string of failures." —Vincent van Gogh

And, of course, there is this classic:

"A setback is a setup for a comeback." —Willie Jolley

So wise, and they're all basically saying the same thing. Failure—or, more accurately, a temporary setback—is just part of the process. The only way you can truly fail is if you quit (or never even start) pursuing something that you're passionate about. Botched attempts are not the end of the world, so just "keep calm and carry on." Yes, I found that on Pinterest, too.

REDEFINE FAILURE.

I think it's time to stop talking about "failure." I realize that it's right there in the title of this chapter, but it's just slowing us down. We've established that failure is quitting something that you care about, and none of *us* is going to do that now, so let's move on. When you're working on a painting, a book, a song, and it doesn't turn out the way you had originally planned, that's not failure: That's learning. That is experimentation, prototype number one, and, most important, it's your jumping-off point for tomorrow. With the right perspective, instead of getting stopped, you can use these lessons to propel yourself forward. Setbacks can be a gift, depending on how you look at them.

THE GIFT THAT GIVES BACK

When you roll up your sleeves to try something new, and it goes horribly wrong, you can look at the result in two ways:

1. The failure can inspire you to keep going. If this new endeavor is something that you are passionate about, something that you want to master, then get up tomorrow and try again. And again, and again, and again until you're happy with the results. Maybe you'll need classes, a mentor, a lot of time to practice—or all of the above—but if you love what you're doing, then this will be a fun adventure full of trials, errors, and a perfect excuse to experiment every day.

2. On the other side of the coin, failure can also be a wonderful gift. How is that even possible, you ask? Well, it can help you realize that certain paths just aren't for you, setting you free to try something else—something that you will love, enjoy, and be excited about. Oh look, here comes another inspirational quote:

"I'd rather be a failure at something I love, than a success at something I hate." —George Burns

Well said, Mr. Burns. In my case, this was painting. I graduated with a BFA as a painting major, so this meant I was supposed to be a painter, right? Painting was always a struggle for me, but I refused to quit. I continued to ram this square peg into its round hole. After my painting professor said, "You should never paint again," in that dreaded critique at the end of my degree (see chapter 7), I took it literally. Mind you, I also stopped making art of any kind. When I did start playing around again, I found myself making mixed-media collages. These pieces came easily to me—therefore, in my mind, they didn't count as "real art." They weren't paintings, and it wasn't a struggle. Obviously this was not "Art," with a capital A. This lasted for more years than I care to admit.

Finally, after *Creative Block* was released, it dawned on me that I was being a giant hypocrite. I was telling other people how to get past their blocks, yet I was terrified to pick up a paintbrush. I decided that it was time to paint again—whether I liked it or not! I went to my studio every day for about two weeks, trying to push through, waiting for it to get fun. I made "ugly" paintings, I had a little stack of paper so I wouldn't worry about ruining the expensive canvases I'd bought—I followed all of my own advice but it wasn't working. Talk about feeling like a failure! But, wait— here comes the revelation. Every time I sat down to paint, I'd find myself wishing that I was cutting and pasting found images instead. All I wanted to do with my precious, scheduled studio time was make collages—so why wasn't I? And . . . exhale. In that moment I completely let painting go and fully embraced collage, because it is the kind of making that brings me that childlike joy that I mentioned in chapter 1. It rarely occurs to me to worry if other people like what I'm making. I love it, and that's all that matters.

So, the next time you're in the studio, think about what you really want to be doing. It may even be something that you haven't tried before. Whatever it is, give it a whirl—you might happen upon the biggest aha moment of your creative life.

YOU SAY FAILURE, I SAY FEEDBACK.

Up until now, we've mostly focused on self-perceived failure, but how do you get back up and keep working after *someone else* deems your work a failure? Your play is panned, your novel gets rejected by the publisher, you didn't sell any paintings at your latest show. This is not failure; it's feedback (and, besides, there is success wrapped up in that as well—you had an art show, wrote a novel, directed a play).

Feedback can be invaluable if you turn it around and make it work for you. Listen carefully, take the pieces that can make your work stronger, and toss out the rest. Negative feedback is not a reason to quit. It's a setback, a bruise, a chance to readjust and then move forward. And you get to decide if you agree with the comments or not. Just getting a bad "review" doesn't mean something is a failure. Somewhere out there a film critic hates your favorite movie—clearly not a failure in your eyes. Or consider the Impressionist painters. In 1863 their paintings were rejected by the all-important Paris Salon, but those artists didn't give up their innovative way of seeing the world. Instead, they celebrated this rejection by starting their own exposition, the *Salon des Refusés* ("exhibition of rejects"). They believed in what they were doing and turned their "failure" into one of art history's most popular movements.

THERE IS PERFECTION IN IMPERFECTION.

"In my own work I do everything by hand. My hand will always be imperfect, because it's human. . . . If I spend a lot of time going over the line and over the line trying to make it straight, I will never be able to make it straight. You can always see the line waver, and I think that's where the beauty is."
—Margaret Kilgallen

This is one of the most beautiful, and freeing, quotes I've ever read about creative perfection. There *is* no such thing; and, in fact, beauty actually lies in the imperfection. Have you ever seen a perfect piece of art, or read a perfect book? Me neither, yet so many of us hold ourselves to an insanely high standard—if it's not perfect we won't do it. The only thing that this results in is a head full of perfect ideas that never ever make it onto paper. Wouldn't it be so much more satisfying to set those ideas free, wavering lines and all? Of course! And even if you end up with a floor full of crumpled paper, you just spent an entire day being creative. That in itself is a victory. And the next morning, when you wake up and pick up your pencil again, those imperfect scraps will be your new starting point.

NEVER NOT BE MAKING.

"Don't think about making art, just get it done. Let everyone else decide if it's good or bad, whether they love it or hate it. While they are deciding, make even more art." —Andy Warhol

You must be willing to get in there every day and just try things, while being totally open to imperfection. Not every idea will become a masterpiece, and that's fine. Your studio is a safe place to play. No one needs to know about projects that don't go anywhere, and remember, all projects go *somewhere*. They all lead to the next piece, either by teaching us something good, or something not so good. The top corner of your collage may be brilliant, even if the rest of it sucks; so, tomorrow, start there. Your short story may be rough around the edges, but that third sentence is a real beauty and could be the beginning of your award–winning novel. Create new starting points for yourself every day. Experiment. Make mistakes. Play some more. This is the path to genius! In fact, let's get started with a few experiments right now.

Find Brilliance in the Scraps.

Remember all that crumpled paper on the floor? That's where we'll start! Grab a stack of paper and go for it. Don't be precious about what you do to that paper. Spend at least thirty minutes sketching, writing, or whatever floats your boat. As you finish each doodle or sentence, crumple it tightly and toss it on the ground. When you're ready, choose one random papery ball off the floor. Uncrumple it and, voilà, *that* is your starting point for today's experiment. Explore that idea in any way you like. Everything else gets recycled (or flipped over to be used later). Not every scrap on the floor will lead to a masterpiece, but there is brilliance down there, you just have to push yourself to find it.

Be Present (A Thirty-Day Challenge).

A quick daily assignment is the perfect way to become creatively present in your everyday life. This is a thirty-day challenge that will make you notice the world around you in a whole new way. Where to start? Here is a list of thirty things and concepts, so that you have no excuse not to start today! Interpret these jump-starters any way you like (photographs, short stories, drawings). Have fun!

CREATIVE JUMP-STARTER IDEAS

1. water
2. circle
3. texture
4. fly
5. five
6. new
7. upside down
8. horizon
9. open
10. vintage

11. blue
12. mirror
13. cold
14. lines
15. noisy
16. boat
17. pattern
18. fur
19. bright
20. sweetness

21. balance
22. cold
23. intersection
24. peak
25. grow
26. red
27. twins
28. simple
29. delicious
30. twilight

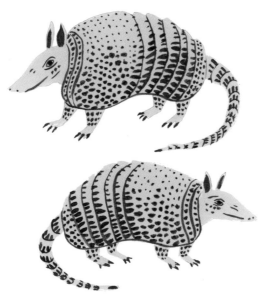

Play Nicely with Others.

Chapter 9 is just around the corner, and it's all about sharing your work with other people, and creating your creative tribe. So, in the spirit of playing nicely with others, choose a friend for this jump-starter. That friend can live in your area or on the other side of the planet. If you're visual artists, then both of you will fill an envelope with found images, scraps of paper, stickers, whatever you've got in the studio that you feel works for this. Pack it up and give it (or mail it) to your friend; you'll receive a packet from your partner. Each of you will then make three collages from each other's scraps. If you're a writer, do the same with a list of random phrases. You can pull these words from wherever you like—overheard conversations, spam subject lines, the dictionary. This is fun, keeps you honest (you don't want to be the jerk who doesn't follow through when your friend is busy working away), and it's a wonderful way to start sharing your work with other people. It also gives you an automatic starting point, helping with that "blank paper" issue from Chapter 4: Blank Paper Can Be Blinding.

All of these quick experiments are both beginnings and endings. Think of this process as a cycle. When you finish one thing successfully, it doesn't mean that you're done, and it definitely doesn't mean that everything from here on out will be easy. Even the creative greats are always still learning, hitting roadblocks, trying again, evolving their work. Wouldn't it be boring, anyway, to master your craft in the first week? Push yourself out of your comfort zone, and never not be making, trying new things, picking those crumpled pages off the floor. The art show, the published novel, the hit song is not the "success." Those events are just the celebration and the cherry on top of all your hard work. True success is loving the process, being creative every day, and failing like a genius.

"When we stop fearing failure, we start being artists."
—Ann Voskamp, Author

CHAPTER 9: CREATING IN A VACUUM SUCKS

Vacuums are dark and dusty, and clearly not a place for creativity to flourish, yet so many of us insist on setting up shop in there. Your lovely sunny studio might as well be a dust-filled vacuum if it's a place where you tenaciously protect your work from the world. But, that vacuum has an Off switch and you can get out of there today. Creative tribes, trusted voices, and encouraging dust bunny–free friends are ready and waiting for you to step out into the light.

SUCKING SOURCE

Where does our reluctance to share our work come from? When did it start? In Chapter 1: Everyone Is Creative, we talked about how much fun it was to make things when we were kids. Drawings proudly taped to the fridge, songs sung at the top of our lungs. Back in those glorious days, it never would have occurred to me to hide my art away. Which makes me wonder: When did that vacuum get plugged in, and who flipped the On switch?

Oh. I think that might have been me.

Somewhere along the way, creativity may have become a solo act for you, too, and hiding your work started to seem like a smart idea. If it's tucked away in your studio, no one can see it. If no one can see it, no one can criticize it. Perfect. If you've ever received a bad critique, it's understandable not to be interested in getting

"feedback." We sometimes convince ourselves that sharing our work would only result in a humiliating, negative experience. So instead we work alone, not showing anything to anyone. But keeping your work hidden, gathering dust? That sucks, too.

Whether it was harsh criticism you faced in art school, rude feedback from a gallery or a publisher, or nasty quips from an unsupportive family member (those may hurt the most), it's *your* job to stay out of the vacuum. Blaming your critics feels like an easier way to go, but ultimately it comes down to you. Remember what we learned in Chapter 7: No One Can Wrestle the Pencil Out of Your Hand. Well, no one else can put your work in a vacuum, either.

LET THE SUN SHINE IN.

Of course, go ahead and enjoy your creative alone time. Work in your studio/office with only a hot cup o' joe and your favorite music to keep you company. Having no distractions is a wonderful, luxurious thing. When you're finished, or feeling stuck, it's time to unlock the door and show somebody what's going on in there.

Creativity needs sunshine to grow, not just daylight. Don't expose your work to just anyone for the sake of putting it out into the world. Creativity requires warmth and nurturing from trusted sources in order to flourish. It cannot bloom in a dark space like a lonely studio with dusty shelves or, worse, left as an idea to roll around in your head never to be brought to life. Your work needs to be created and shared with a supportive audience. Easier said than done, yes? Here's how to start.

1. **Share with the Universe.** Before you reach out to anyone else, have a little chat with the universe. Write a letter explaining *exactly* what you want. You may crave a fulfilling art career, but what, specifically, does that mean to you? Selling a painting for more than five hundred dollars? Landing a gallery show or a book deal? Seeing your work in a national publication? Tuck this letter away in a safe spot and reread it occasionally, or lock it away for a designated period of time.

Later, you'll be shocked by how many of your goals will have been realized in a relatively short period. I put my letter away and then totally forgot about it for almost two years. When I accidentally found it, folded neatly into the back of one of my notebooks, more than half of my wish list had already happened! I guess the universe was listening. Or maybe, by taking the time to think through what I wanted, and also to physically write it down, those goals became less fuzzy in my mind and were able to find their way subliminally to the top of my priority list. Just a hunch.

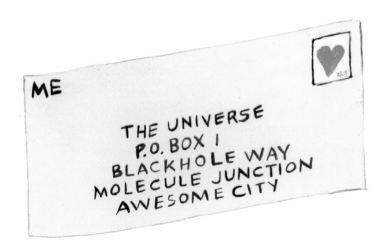

2. **Fake It Till You Make It.** Go ahead. Tell people that you're an artist, writer, filmmaker, etc.—even if you don't completely believe it yet. The first step in sharing your work is owning the fact that you're a creative person, and a valid part of the creative community. When you own that title, and share it with others, it exposes you to a whole world that you might not be tapping into if you instead choose to say, "Oh, I'm not an artist, I work in a cubicle." Remember, you can totally be both (see Chapter 3: Labels Are for Canned Peaches, Not People).

3. **Show Your Work to Other Human Beings.** This is where things get scary. The moment you show your work to another living, breathing human, you open your work up to criticism. I almost said, you're opening *yourself* up to criticism, but we have learned (see Chapter 7: No One Can Wrestle the Pencil Out of Your Hand) that criticism of your work is not criticism of you as a person. The key is to share with people you trust, people who will give you constructive feedback. They may have suggestions about new ways that you can look at your work. And, if you trust them and respect their opinions, this kind of criticism ("feedback") will make you better at whatever it is you do. That is an *invaluable* gift for any creative person.

I know this list very well, as I've lived all three steps outlined above. It took me years to figure it out, so I'm trying to get you there a little faster! I wrote my letter to the universe. Through clenched teeth, I started telling people that I was an artist. I still wasn't showing my work to anyone, though, until I found myself in the middle of a giant creative block, with a deadline looming. I realized that it was finally time to open the studio door and ask for help.

FIND YOUR TRIBE.

The quest to find your people may seem daunting, but it delivers a huge reward. I enjoyed one of the most creative, collaborative afternoons ever at a time when I suffered from major creative block around a gallery show I was due to hang. I took a deep breath and mustered the courage to approach two local artists for advice. I didn't know Jessica Bell and Sarah Gee Miller very well, but I emailed them anyway. We met. Those wonderful women listened, shared their own experiences, and talked me straight out of my crippling creative block. From that day forward, I was a believer in the power of reaching out. It can be insanely helpful to share with the right people. I had started to create my "tribe."

To this day, I'm on the lookout for smart, caring, talented people to add to the roster. If you are still trying to assemble your creative crew, these tips might help. Just do one, or try a combination of all three:

Write down the names of three people you trust and admire creatively; they may or may not be the people to whom you confessed your green-eyed jealousy (see Chapter 5: A Green Eye Is a Green Light). Invite them, one at a time, to meet (in person or on Skype), and tell them you'd like to get their feedback on your work/life/whatever. After what will hopefully be a truly interesting conversation, and before you say good-bye, ask them to write down three positive things about what you're working on. Put that list somewhere special and call on it when your inner critic is getting feisty. Words from these people, who you trust

and admire, should hold much more weight than your inner critic's jabs.

Once you have connected with everyone you've invited on the coffee dates, why not bring all of them together? Start a creative group that meets regularly, so that you can be creative together. One of the most fun ways to do this is to start a "Bad Art Night." Set out with the goal of creating the worst thing you've ever painted, drawn, sewn, or written. The results will be hilarious, and because you've made the ugliest thing possible, there will be nowhere for your work to go but up! These creative groups are not only a safe environment to experiment with new ideas, they're also a great place to get more comfortable with showing other people what you're creating. You can't hide your process when it's all happening on the same table! And while you're there, remember to be generous with supportive feedback for the other members of your newly formed club, because, as Mom always said, "Treat others the way you want to be treated."

If you prefer to create in the quiet of your own space, you can do a different kind of get-together by forming a group that meets regularly to discuss finished work or work-in-progress. American painter Leah Giberson told me about a fantastic group that she and some of her friends started two years after graduating from art school. They missed the mutual support and feedback that they had gotten when they were students, so they decided to meet once a month to share their work in a typical art-school critique format—each artist taking a turn to show her work. According to Leah, there was definitely still criticism, but it was always constructive. Because they trusted each other's opinions, they could share what they were working on, discuss any trouble they might be having, and give and take advice in a supportive environment. She said, "It was important to each of us that we encourage one another to push beyond our comfort zones and continue to grow as artists." Leah also shared this insightful gem with

me, which is a perfect throwback to Chapter 2: Excuses Are the Enemy and is helpful on so many levels:

> **"Most of us in the group had full-time jobs and/or young children, which made it difficult to get much studio time. Without the monthly commitment to our group, it would have become all too easy for many of us to let our art fall to the side. Instead our monthly studio visits created deadlines that encouraged us to make new art (even if in spurts) and continue feeling like working artists."**

Note: If you can't organize a group like this in the place you live, you can find your tribe online. Private Facebook groups are perfect for this, as long as your group is filled with people you trust!

Leah's story is a wonderful example of the importance of finding your tribe. Having others to rely on is an effective way to prevent creative relapses. Sometimes when you're on your own, or feel like you're on your own, you may slip back into old patterns—not making time for your work, stopping yourself before you start, listening to your inner critic. By being part of a group, even just a group of two, you've got someone cheering for you on the days when you feel like quitting. It's also a really great excuse to hang out with fun, like-minded people on a regular basis.

WHEN YOU SHOULD NOT SHARE

Although I just spent most of this chapter saying how important it is to share your work, and to let it out into the light, there are two important exceptions.

1. **Don't share big ideas with small thinkers.** If you know that someone is negative, *do not share your work with him/her.* You know who I'm talking about! In most cases, it will slow you down or stop you completely, and will add fuel to your inner critic's fire. No good can come from that—no good, I say!

2. **Don't share with the entire world—until you're ready.** You don't have to share *everything*. With social media in every corner of our lives, it may feel like you should be posting/tweeting/pinning every sketch, video, piece of prose. You don't have to and you shouldn't. Share when you're ready, when you're proud, and when you want genuine feedback. That's what your tribe will give you. Internet trolls, on the other hand, are a little less supportive. Once you feel confident enough to ignore them, go forth and tweet to your heart's content. (See Chapter 7: No One Can Wrestle the Pencil Out of Your Hand, for more thoughts on dealing with online criticism.)

A vacuum is a very lonely place, with room for only one person. How can you host a Bad Art Night or a feedback group in a vacuum? Well, you can't—there's not nearly enough room for all of the chairs and snacks you will need—so it's time to get out of there. Immediately.

If you don't already have a creative tribe, today is the day. A few paragraphs back, I asked you to write down the names of three people that you could reach out to. If you haven't written that list yet, do it right here, right now, in those super-wide margins, and then take action. Just imagine how thrilled you'd be if someone invited you out on a creative coffee date? Exactly.

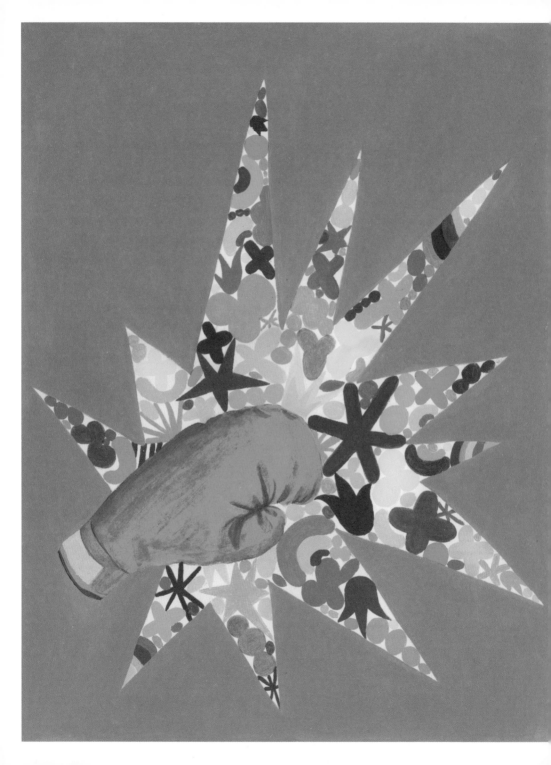

CHAPTER 10:
BLOCKS ARE MEANT
TO BE BROKEN

Here we are, the final chapter. I did it. I wrote a whole book. Almost. The only thing left to do is to write a chapter about creative blocks. And I've got nothing. In fact, I Googled "creative block" to see if any fog-clearing information would pop up to save me. I found a huge number of top-ten lists, articles, videos—oh, and my book *Creative Block*.

We know. You already wrote about that. Can you possibly say anything else on this topic that people will actually find helpful?

Well, yes, now that you mention it, I have quite a bit more to say on this subject. Thank you for your feedback. (BOOM! Beat him at his own game!)

As soon as *Creative Block* hit shelves in 2014, almost overnight I was seen as an "expert" on creative blocks and was invited to speak at all sorts of places, from high schools to Pixar to Oprah's studios. I was there to share the insights that I had gleaned from writing the book, which I did, but I cannot even tell you how many personal aha moments I experienced in the months *following* the release, thanks to everyone I met along the way. I heard countless, teary-eyed, "me too" stories from people who thought that they were the only ones ever to experience a

depressing, creativity-halting block. I was given block-bashing tips and tricks by little kids, creative professionals, and senior citizens. I drank a lot of coffee and had long, deep, interesting discussions with so many amazing people about what it meant to be blocked and ways that we could all find our way out of that dark box. Those enlightening conversations and experiences are what this book is truly about. I should not be the only one to benefit from all of those moments. I want to share these ideas, so that all of us can knock down those blocks and find our way to the other side. Let's begin with the biggest aha moment of them all.

Blocks Are Just Part of the Deal.

That *does* seem rather simple for my biggest revelation. But it *is* that uncomplicated. Blocks will happen. Not only are blocks proof that you're human, they're also your ticket into a very cool club— a club filled with every other creative person in the world! You should never feel ashamed about being blocked. In fact, I think blocks should be worn as one of your club membership badges! The moment you accept that blocks are just part of the process— that they *will* happen—suddenly this whole thing becomes a lot less scary.

As Easy as 1-2-3

This was my next realization. In *Creative Block*, I asked artists how they dealt with the inevitable block, and three very common ingredients came up over and over again. Here is a trio of block-breaking antidotes that every creative person should have in his or her back pocket:

1. Embrace imperfection.
2. Get into the great outdoors.
3. Make rules.

Now, what do you with these remedies? You can combine them into one giant block-knocking solution, or you can savor each one on its own:

Imperfection

That's right, screw perfection. Celebrate *imperfection* instead. There's no such thing as a perfect painting, a perfect book, a perfect song—so why worry about trying to achieve that? Besides, more often than not, imperfection is far more interesting than perfection. Embrace the happy accidents—they might just lead you to something totally new (see Chapter 8: Failure Leads to Genius).

The Great Outdoors

Yes. Go outside. If you're in the middle of a block, I can almost guarantee that sitting in your studio staring at a blank page is not going to bring you the inspiration you're looking for. Open the door and head out into the world, if only for an hour. Fresh air and new surroundings go a long way when it comes to getting through a block (see "Roll the Dice" at the end of this chapter for a fun way to be creative outside).

Rules

This keeps coming up. So many successful creative people swear by rules. As mentioned earlier in the book, one of the best ways out of a block is to set constraints for yourself and then play within them. In Chapter 4: Blank Paper Can Be Blinding, you'll find the "Top Ten Rules to Play Within."

STORM BEFORE THE CALM

Here you are, doing everything right. Your inner critic is slowly becoming your inner cheerleader. You're sharing with trusted sources. And you've accepted that blocks are just part of the process. Why, then, is it still so upsetting when your idea tank is on empty? Because it is. It's distressing, frustrating, *and* really annoying. I think everyone wishes that creativity would just flow with the turn of a tap, but it doesn't always work that way. This was my next big lightbulb moment: Even if you're at the top of your game, you will have days when you feel sad, mad, and frustrated because of a block. That, unfortunately, is also part of the deal. The tortured artist syndrome again. My advice? Don't beat yourself up for feeling this way; it's normal. But, at the same time, don't get stuck down there. Remind yourself, insistently, that you won't feel like this forever. Toronto–based artist Amanda Happé has a very insightful perspective on blocks:

"I think I might get creative blocks all the time, but haven't thought of them that way. I frequently have nothing interesting to say. Those strike me as great times to keep creatively quiet. I think we're too hard on ourselves if we expect an uninterrupted procession of meaningful creation. Let it be. But lay in wait. Keep your ears perked and your soul soft for that new impulse."

Brilliant!

ELIMINATE THE SOURCE.

Sometimes you just feel stuck, and you're not even sure why. Blocks can come from so many places, and the sooner you identify the source, the sooner you can address it and potentially limit future blocks. Think of it like a plumber trying to figure out what's clogging a pipe. You have to get in there, poke around, and get things flowing again, or you're going to have a huge mess on your hands. Here are a few of the most common obstructions.

Inner Critic

It's so hard not to blame this guy for everything, but obviously the inner critic is a major factor in pretty much every creative block. I almost didn't write this chapter because that voice was telling me I couldn't. If that voice gets too loud and persuades you to quit then it wins, and you're the one that suffers. But, when you quiet your inner critic by getting up every day and failing like a genius, getting out of that lonely vacuum, and turning a green eye into a green light, it's almost impossible to be blocked. Remember: You're the boss.

Outside Criticism

I won't sugarcoat this one. It is hard (and probably my biggest source of blocks). Harsh, hurtful criticism can be like a giant boulder tossed in the middle of your creative path. Sometimes the unhelpful words come from people you know. Other times, the messages are delivered by complete strangers with too much time on their hands, and too many social media accounts.

Not only does it sting when it happens, but it can also make you put walls up, stopping you cold. My tactic for years was to simply create nothing. My imperfect logic was: If I don't make anything, no one can say anything mean. So how do you knock those walls down? More outside feedback. I know, that is likely the last thing you want at this point. But take a deep breath and reach out to that wonderful group of trusted sources that you've surrounded yourself with. They might think you need to take a new look at what you're doing, too, but they will deliver it in a way that leaves you feeling excited, motivated, and ready to start working again.

Deadlines

Your project is due, and you've got nothing. [Insert giant block here.] Deadlines are an interesting thing: in some ways, a wonderful motivator—they force you to stop procrastinating—and in another way, they're terrifying. That looming deadline can make you feel like a deer in headlights. Here is some very practical advice on this, given to me by countless creative professionals. When you're working on a project with a deadline, *build in* time to be blocked, right up front. If you know it will take you about two weeks to complete this work, then allow yourself a full month, because it's just a given that blocks will happen. It's not a big deal, just a fact. Give yourself permission to have blocks, and stop 'n' starts. It will take the pressure off.

Commissions

Somebody loves your work and wants you to create something just for them. Wonderful! Yet strangely scary at the same time. Suddenly you're not free to do whatever you want, and you may start to freeze up. Don't forget: They hired *you.* They want you to do what you do best. So do it. And if you read the previous paragraph, I know you'll be sure to build some time to be "blocked" into your schedule.

Life

Oh yeah, that. Day-to-day life is a huge source of creative blocks—breakups, moving, stressful work situations, kids on summer break . . . the list goes on. When life is happening all around you, very often the first thing to go is your "frivolous, totally selfish" creative time (thanks, inner critic), but I have a theory about that. In order to get through the stuff that life throws at you, *continuing* to be creative may be exactly what helps get you through. You might think of creativity like exercise. When you're overwhelmed by life, the last thing you want to do is go for a run or to the gym; but, in fact, it may make you feel better. Make time and space for creativity, even when there seems to be no time or space for anything. It will have an energizing effect.

KNOCK-A-BLOCK

We've established that blocks will happen, so you may as well figure out a fun exit strategy! Throughout this book, there are tips and tricks, and lists of exercises, that can help you do exactly that. Here's a little cheat sheet to help you find all of them quickly:

Need more? No problem. Here are five more block-breaking tips:

1. **Work in the moment.** Don't worry about what's coming next, what you'll make, when you'll get out of the block—just do. Right now. If you spend your time and energy worrying instead of creating, you'll never get to the creating part. It's possible to spend years thinking about what you should be making. The desire for perfection is sometimes paralyzing. Start forcing yourself to make at least three or four quick pieces every week, even if you think they are "terrible." With this production schedule, you will see the light at the end of the tunnel.

Remember this tip from chapter 4: Prepare a stack of cheap and cheerful surfaces ahead of time, so you will be less focused on that one perfect, expensive canvas in front of you (that one perfect, expensive canvas that you've been terrified to "ruin"). With a stack of paper and no pressure for perfection, you can just go, toss what you've done on the floor if it sucks, grab the next sheet, try again. That one will most likely suck a little less, and so on. Try it.

2. **Do something mundane.** Years ago, when I took improv comedy classes at Second City, my brilliant teacher there, Frank, said the best way to tap into the creative side of your brain is to do really boring, everyday stuff. Have you noticed that great ideas pop into your head when you're in the shower, or washing the dishes, or driving across town? When your left brain is busy taking care of utilitarian jobs, your right brain is free to let loose and get creative. As mentioned in chapter 2, it can help to procrastinate with purpose. I get into a groove by cutting bits and pieces from my thrift-shop book collection, not creative, just very methodical. Its wonderful side effect: It almost always sparks a ton of ideas.

3. **Roll the dice.** This is one of my favorite block-breaking activities. It is a project from *Creative Block*, given to us by Australian ceramicist Mel Robson:

"Choose a mode of transport—bike, train, foot, bus, car, roller skates, unicycle. Throw a die to determine how long you will stay on that mode of transportation. A 3 followed by a 2 means you stay on for 32 minutes. A 2 followed by a 4 means you stay on for 24 minutes. Ready? Go!

"Ride for this amount of time, and then stop. This is where you can spend the next hour (as long as you feel safe). Explore. Observe. Collect. Walk around, watch, draw, talk, sing, listen, sit, take photos, record sounds—whatever takes your fancy. Just explore somewhere new. Really take notice. The idea is just to let something completely random perhaps lead you to something new."

When you've got fresh air, new surroundings, and an interesting adventure, there is not a lot of room for blocks. Grab a die, and get out there!

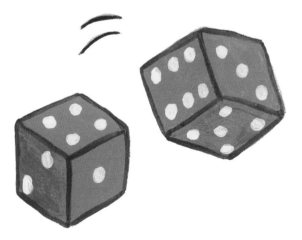

4. **Keep bedside notes.** Keep a notebook beside your bed. Right before you go to sleep, write a few paragraphs about your current project and what about it is frustrating you. Go to sleep, and then as soon as you wake up, write about the project again. Sometimes a good night's sleep and a weird dream will help get ideas moving.

5. **Do what you hate.** If all else fails, do something that you really don't want to do, like your taxes. Suddenly doing something creative will seem like a much better alternative.

THE ZONE

Alright, let's stop focusing on being blocked and talk about that magical, time-defying, golden place that dwells on the other side of blocks: the zone. Ideas are flowing. You don't want to stop for food or bathroom breaks, and heaven help anyone who tries to interrupt you. Sometimes you just accidentally arrive here, on days when you least expect it. Other times, you have to push on the door a little harder; all of the exercises above can help you with that. You might start out playing around with a little project that seems simple or silly, but before you know it, the creative sparks are flying, the music gets turned up, and suddenly it's 3 a.m. This is what it's all about: those perfect moments when you are just making, writing, creating, living! Relish it, roll around in it, and pay attention to how amazing it feels. The next time you're stuck, trust that the zone is waiting for you on the other side—and it will be magical.

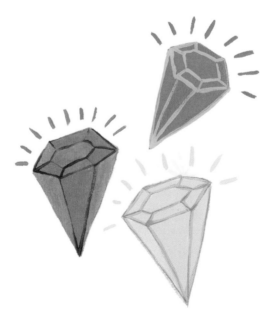

WELCOME TO THE CLUB

Well, there you have it—ten truths about what it means to be a creative person. Experimenting, carving out time for creativity, finding your tribe, making criticism work for you—the repeating themes within these truths overlap and intersect, and when woven together they make up the intricate tapestry that is a creative life. There will be snags here and there, but this creative journey is made even more beautiful and interesting by a bit of imperfection thrown in for good measure.

It is not a simple thing to be a creative person. It's emotional, it's exciting, and rewarding, and challenging. The one thing a creative life does *not* have to be, however, is lonely. We are not alone. By standing up and owning our "I am creative" labels, we have automatically been initiated into a giant, creative club with members of all ages and all skill levels, from every corner of the world. The ten truths laid out in the ten chapters of this book apply to every single member of this club. Even the greats who appear to "have it made" experience days when ideas just don't show up—but that's okay, because they will just pick up their pencils and try again tomorrow. The other benefit to membership? You have a huge creative tribe to call on whenever you need them—whether you want someone to bounce ideas around with, or you're looking for a shoulder to cry on after some unwanted criticism, or, even better, you need someone to pop the champagne with when it's time to celebrate a creative success.

I hope that this book, with its advice, stories, and project ideas, will bring you a truckload of life-changing revelations. Remember the joy in creating just to create. Embrace the wavering line. And tell your jerk of an inner critic to take it down a notch, or he won't make it through the clubhouse door.

ACKNOWLEDGMENTS

This book is the culmination of so many moments and lessons that I have been lucky enough to have experienced in the past few years. I met countless people who generously shared their stories—uplifting, funny, and, in some cases, crushing. Their openness and honesty were beyond inspiring. I am also incredibly grateful to my editor Kate Woodrow. She convinced me that I was capable of writing thirty thousand words, and cheered me on when I wasn't so sure that she had been right. Martha Rich is next on my gratitude list. There was no other artist that I could have imagined illustrating this book, and I loved every minute of our collaboration. The next thank-you goes not to a person, but to a thing: Booth #102 at Local. Yes, this entire book was written from a lovely, lakeside restaurant in my hometown. They tucked me away in a cozy, quiet corner where I could focus—and then they brought me a lot of coffee. And, finally, I thank the two most important people in my life: my husband, Greg, and my son, Charlie. They are the most supportive, loving, and proud cheerleaders in the whole wide world, and I love them more than words can say.